UPPER PENINSULA BEER

UPPER PENINSULA BEER

A HISTORY OF BREWING ABOVE THE BRIDGE

RUSSELL M. MAGNAGHI

AMERICAN PALATE

Published by American Palate
A Division of The History Press
Charleston, SC 29403
www.historypress.net

Cover image courtesy of Karl Racenis.

First published 2015

Manufactured in the United States

ISBN 978.1.62619.568.4

Library of Congress Control Number: 2014954496

CONTENTS

ACKNOWLEDGEMENTS

Robert Archibald, Gwinn
Ray Bauer, Sault Ste. Marie
Bayliss Public Library, Sault Ste. Marie
Ted Bays, Marquette
Beaumier Heritage Center, Northern Michigan University, Marquette
Dave Beckwith, Grand Marais
Tom Belt, Marquette
Gary Beyer, Ishpeming
Sue and Tim Bies, Calumet
Paul Boissevain, Houghton
Central Upper Peninsula and University Archives, Northern Michigan
 University, Marquette
Derek "Chumley" Anderson, Marquette
Jay Clancey, Ishpeming
Ed Cuyler, Marquette
Richard Dana, Calumet
Terry Doyle, Marquette
Duane Forest, Sault Ste. Marie
Richard Grey, Houghton
Beth Gruber, Marquette
Bob Jackson, Houghton
Kelley Kanon, Grand Blanc
Diane D. Kordich, Marquette

Acknowledgements

Andy Langlois, Marquette
Voncel Le Duc, Manistique
Lark Ludlow, Paradise
Grant Lyke, Chocolay Township
David Manson, Marquette
Jason Markstrom, Sault Ste. Marie
Marquette Regional History Center, Marquette
Joseph Meni, Forsyth Township
Rosemary Michelin, Marquette
Michigan Technological University Archives, Houghton
Jeff Pavlik, Farmington Hills
Ken Pitawanakwat, Marquette
Martin Reinhardt, Marquette
Brian Richards, Ishpeming
James Shefchik, Marquette
Josh Smith, Comstock
Tim Soucy, Chocolay Township
Mike Stratham, Escanaba
Matthew Sviland, Escanaba
Rebecca Tavernini, Marquette
Dan Truckey, Marquette
Bill Van Kosky, Marquette

1

GETTING STARTED IN THE UNITED STATES AND THE UPPER PENINSULA

B efore we get started, it is best to look back at brewing in the United States, to see where and how the process began and how we have reached the age of microbrewing in the Upper Peninsula of Michigan. Beer was first brought to the Jamestown colony following its settlement in 1607. The first commercial brewery in the United States was opened by the Dutch in New Amsterdam (modern New York City) by the 1640s. Twenty years later, there were ten breweries in operation. In the early days, when ingredients were difficult to obtain, colonists experimented with maize, pumpkin—whatever they thought would make a good beer—just as microbrewers do today. The history of colonial America is also a history of early brewing in the United States. The English produced ale, so its use soared. As a result, wine never gained a foothold as it did in New France (modern-day Canada).

This early era of beer was transformed with the arrival of German immigrants who were fleeing unrest and revolution in Germany in 1848. They brought with them lager beer based on several different styles from central Europe. Pilsner beer used mild Bohemian hops, barley and rice, but corn gradually won out. The oldest brewery in the United States still operating is D.J. Yuengling & Sons of Pottsville, Pennsylvania, founded in 1829.

Megabreweries

German immigrants arrived in the Midwest and settled in Chicago, Milwaukee and St. Louis and opened breweries. They found that they were in the center of the country with efficient rail lines for easy beer distribution. Blatz, Schlitz and Miller opened breweries in Milwaukee, while Eberhard Anheuser and Adolph Busch merged to form the Anheuser-Busch mega giant. Anheuser-Busch was aided by the use of the refrigeration car and the introduction of bottled beer. These breweries with the capacity to dominate the national market would be a serious and constant challenge to the German brewers of the Upper Peninsula, located a few hundred miles to the north with excellent rail connections.

American brewing thrived until the passage of the Eighteenth Amendment—the advent of national Prohibition in 1920, making the manufacture and sale of alcohol illegal. This unfortunate situation lasted until 1933 and the passage of the Twenty-first Amendment, which repealed Prohibition.

Alcohol was legal again, and breweries were quickly reestablished. World War II helped expand the industry. Although at first, some temperance groups tried to say that grain was needed to feed the troops and should not be used for beer. The brewers quickly pointed out the health benefits of brewer's yeast—vitamin B and thiamine—for the diets of soldiers and defense workers. They won the argument but had to produce 15 percent of their beer for the military. The large breweries flourished, and between 1941 and 1945, sales increased by 40 percent. During this time, small breweries were all but nonexistent. The growing large breweries—Anheuser-Busch, Miller and Coors—produced a pilsner-style beer using low-cost ingredients, such as corn or rice, which provided little flavor to the finished product. As a result, American beer was considered poor in quality and flavor on the international beer scene.

The Resurgence of Local Brewing

In the first decade of the 1970s, when the fewest breweries existed in the United States, changes began to take place that created the modern microbrewery scene. In 1976, Jack McAuliffe established the New Albion Brewing Company in Sonoma County, California. Although it lasted only

seven years, it was the foundation of small breweries after Prohibition. Small brewers had hope, and it ignited an interest in craft brewing. Soon after New Albion's start, Ken Grossman opened the Mendocino Brewing Company, the first brewpub. The hallmark date for microbreweries was October 14, 1978, when President Jimmy Carter signed HR 1337, which legalized homebrewing "for personal or family use and not for sale." This made brewing equipment available and stimulated homebrewing. As brew guru Charlie Papazian reported, 90 percent of the pioneer craft brewers got their start homebrewing.

The second step that touched off craft brewing was the legalization of brewpubs, first in California in 1981 and soon in all fifty states. Microbreweries and brewpubs were legalized in Michigan in 1993. The rise of craft beer has been strongest in the Midwest, the Mountain West, the Pacific Northwest and California.

American craft beers have emerged from traditional European styles to local variations based on popular appeal and experimentation. Microbreweries in Michigan can now manufacture up to sixty thousand barrels of beer annually and serve their product on the premises or sell beer in growlers for offsite consumption. Michigan has a three-tier system whereby a brewery pays an excise tax on the barrel and sells its product to a state-licensed wholesale distributor who pays a tax. The brewery and distributor determine the distribution territory. The distributor then sells to the retailer, who pays the state sales tax. A brewpub is a brewery that sells its produce on the premises or operates as a restaurant. All licensing is under the Michigan Liquor Control Commission.

On March 25, 2014, Governor Rick Snyder signed a nine-bill package from the legislature, which has had a positive impact on the further development of microbreweries in Michigan. It doubles the amount of beer microbrewers may produce, from thirty thousand barrels per year to sixty thousand. It also allows brewpub owners to now have interest in five other pubs, up from the previous two, so long as the combined barrel production does not exceed eighteen thousand barrels per year. In addition, small microbreweries, producing less than one thousand barrels annually, are now able to distribute their product directly to retailers under certain conditions. "Michigan-made beer is award winning and world renowned," Snyder said, "We have the fifth-largest number of microbreweries and brewpubs in the nation, and this legislation will empower our great craft beer industry to keep growing." In response to the governor's statement, the Michigan Brewers Guild stated that the brewing industry contributes more than $133 million to the economy and more than $24 million in wages.

Beer crafters experiment with a variety of ingredients, but hops allow them to create new flavors and styles of beer. The largest hops farms are in Washington, Oregon and Idaho. Since 2007, over four hundred acres of hops have been developed in Michigan. The American hop varietals are: Amarillo, Cascade, Centennial, Chinook, Citra, Columbus, Nugget, Simeo and Tomahawk. Wild hops have survived in Michigan, but without knowing which variety they are, brewers have shunned them because they can't know what the resulting flavor will be.

Pale ale is pale malt developed through warm fermentation. India Pale Ale (IPA) is a hoppier version of pale ale. With the addition of more hops, it is known as double, or imperial, pale ale, with a 7.5 percent alcohol content. American pale ale was developed in the 1980s with a significant quantity of American hops and 5 percent alcohol. Stout is a strong, dark beer brewed with roasted malt or barley. Lager is a light beer brewed by slow fermentation and is matured under refrigeration. Pilsner was first developed at Plzen, in the Czech Republic, and is a light beer with a strong flavor of hops.

Craft brewing has become a major industry throughout the United States. Today, Michigan, with over 150 breweries, is ranked fifth in the nation. Between 2007 and 2012, sales nearly doubled from $5.7 billion to $12 billion. Sales are predicted to rise to $18 billion in 2018. This rise in beer sales has taken place at a time when domestic and imported beer sales have remained flat.

Who is buying and drinking craft beer? Studies show the consumer is in the twenty-five- to thirty-four-year-old age group, while 32 percent of the baby boomers favor craft beer.

A number of sources are aiding the further development and expansion of the craft beer industry. The legislative actions by various states have greatly assisted the industry. The Brewers Association, on the national level, and state associations, on the local level, have worked with brewers to aid in state legislation and to directly assist brewers with workshops and other events to promote the industry.

WHERE AND WHAT IS THE UPPER PENINSULA?

The Upper Peninsula is a unique and clearly defined region of the state of Michigan. It is separated from the Lower Peninsula by the five-mile-wide Straits of Mackinac. Since 1959, the Mackinac Bridge has united the two.

On the north is Lake Superior, to the east and southeast is Lake Huron, to the south is Lake Michigan and to the west is the state of Wisconsin. It is a forested region with a population of 311,361 (according to the 2010 census). Its largest city, Marquette, is home to 21,491 residents.

It is a land of distances, running for three hundred miles from east to west and some two hundred miles from the north to south at its farthest points—Copper Harbor to Menominee. Today, it is a land for the vacationer, with vast tracts of forests and miles of streams and lakes that attract sport fishermen and hunters. Its miles of trails attract hikers, snowmobilers and bicyclists. It is a land where good brew has always been appreciated.

The Upper Peninsula, or UP, whose people are known as Yoopers, is easily identified as a unique region with its own heritage and lore. Native American settlements in the area date to 9000 BC. The Native Americans who encountered the French explorers were Anisnaabe (which include the Odawa, Ojibwe and Potawatomi), who had learned to cope with the relatively harsh environment of short growing seasons and long, sometimes brutal winters.

During the colonial era (1620–1796), the area was controlled through Canada by the French and, after 1760, by the British. Both nations used the fur trade as the economic base for entering and settling the area at Sault Ste. Marie and fifty miles to the south at the Straits of Mackinac. While the first beer, spruce beer, was introduced at this time, it never became popular because the fur traders instead exchanged brandy and rum to the Native Americans for the furs they gathered during the winter.

A new era dawned in the 1840s with the simultaneous discovery of iron and copper. William Burt found iron in the central UP, to the west of Marquette. Douglass Houghton found copper some ninety miles farther to the west, in what became known as the Copper Country (Houghton, Keweenaw and Ontonagon Counties). In the mining and logging industries that came along, the need for laborers was filled by native-born Americans and thousands of European immigrants willing to leave their homeland for the opportunities America offered.

One of the first groups to arrive was the German immigrants fleeing unrest in their native land in 1848. They brought with them the art of brewing, which they began practicing in the Upper Peninsula in 1850. This tradition blossomed and grew for nearly seventy years. Breweries emerged in all of the larger communities in the UP. In 1916, Michigan voters approved state prohibition, which brought that golden age of brewing to a close.

The end of national Prohibition in 1933 saw a few of the local breweries reopen their facilities, but most were ghosts of the past. Even those that opened had to deal with strong competition from the large breweries to the south, especially from Milwaukee. The last UP brewery of the era—Bosch—closed its doors in 1973. Twenty-one years passed before the region's first microbrewery, Hereford and Hops, opened in Escanaba.

Since that time, the craft brewing industry in Michigan and the Upper Peninsula has developed by leaps and bounds. It now flourishes, with over 150 craft brewers in the state of Michigan. Today, the number of craft breweries in the UP exceeds the number that closed in 1918.

As of this writing there are sixteen microbreweries in operation in the UP, and a number of others are planning to open. Most of these microbreweries and their taprooms have become centers of community life. They have revived interest in downtown settings, attracting both the local population and tourists. In a number of cases—such as for Blackrocks, Ore Dock and Keweenaw Brewing Companies—the breweries have gone into canning and bottling and reach out to state and regional markets. As a result of this new industry, many areas of the region suffering from economic decline have seen the brewing industry bring life back to the community.

The Upper Peninsula has entered a new era of brewing and consumption of beer, which has become a community and social activity, much like coffee shops. Getting to this point, however, has been a long road.

2

COLONIAL UPPER PENINSULA

The story of beer in the Upper Peninsula can be traced to the province of Québec. Settlers there introduced various types of brewed products. When the French settled Québec under Samuel de Champlain in 1608, they found the land ideal for making beer, as they could grow hops and barley and there was plenty of pure water. The first colonists—Louis Hébert and his wife, Marie—made beer for their own use in 1617. In 1633, Champlain mentioned cooking a feast "in a great kettle which is used for making beer." A year later, the Society of Jesus Catholic (the followers of which are called Jesuits) missionary Paul Le Jeune wrote that the "Jesuits would like to have some beer but they would have to wait until a brewery is erected." Later in 1646, Jesuit brother Ambroise was employed "preparing barley" and making beer, and in March 1647, the Jesuits made beer at Sillery for the first time for their own use. At the same time, Québec gained another brewery called *La brasserie de l'habitation*, which burned down in 1649. Another brewery was opened in Montréal at about the same time but promptly failed. Cider, beer and wine were consumed on feast days, and at Midnight Mass in December 1664, members of the choir were a bit overtaken by beer.

In 1665, Jean-Baptiste Talon arrived from France as the new economic minister or intendant. He was immediately appalled at the amount of money spent on the importation of French wine. Two years later, he received royal permission to establish a brewery at Québec. He hoped this enterprise would cut down on wine and brandy imports and encourage farmers to plant barley and hops. To show his support, he planted six thousand poles

of hops on his farm. *La brassiere du Roi* was soon in business and produced a dark ale. This ale was exported to France's Caribbean colonies in 1671. This early effort was ended when Talon left the colony. Others tried to develop their own breweries, but they failed. Nevertheless, brewing continued as a cottage industry.

Earlier in the seventeenth century, the French part of Canada, which was known as New France, entered the region that is now the Upper Peninsula of Michigan. When the first known French explorer, Étienne Brulé, arrived in 1620, he saw a great abundance of furs, especially those of the beaver, and reported this to authorities in Québec City. Soon the Upper Peninsula became the center of the fur trade in the mid-continent. The Iroquois, Dutch and English struggled to enter the area and drive out the French. This never happened, and the French fur traders and, later, Jesuits missionaries, settled the area in small numbers and relied on the Native Americans to trade with them and be converted to Christianity. Beer was given to the Native Americans on a limited basis. Two relatively small settlements arose: Sault Ste. Marie on the north side of the peninsula, along the St. Mary's River at the gateway to the Lake Superior country, and St. Ignace to the south on the Straits of Mackinac. This settlement also included Fort Michilimackinac on the south side of the straits, and although just outside of the Upper Peninsula, it was a major settlement in the region.

The French occupation of the region continued until the end of the French and Indian War in 1763, when the Treaty of Paris transferred the Great Lakes region to the English. They were new rulers, but little changed in the European relationship with the Native Americans, which continued to be based on furs exchanged for rum and manufactured goods. In the early 1780s, the English decided to relocate their settlement at a more defensible position on fabled Mackinac Island. The colonial era lasted in the Upper Peninsula until 1796, when the United States finally took control of the region.

SPRUCE BEER

Spruce beer was a very common and popular drink throughout northern colonial North America, and the French were common drinkers of it. The origins of this beer go back to the winter of 1535–36 when the French explorer, Jacques Cartier decided to winter in Canada near modern Québec City. By February, the lack of a balanced diet with fresh fruit and vegetables

led to a lack of vitamin C and caused most of his men to come down with scurvy; a number of them died. Dom Agaya, son of an Iroquois chief, told them to boil the tips of coniferous trees, such as spruce, fir or cedar and then drink the infusion. Cartier's men boiled the bark of a white spruce tree in water, and the resulting tea quickly cured the sickness. Cartier considered this a miracle. Future French colonists used the knowledge of the efficacious nature of spruce tea in preventing scurvy during the long winters when vitamin C was scarce.

The French widely used spruce beer, or *biere d'epinette*, which evolved from the original tea. By 1749, Pehr Kalm—a Swedish-Finnish explorer, botanist, naturalist and agricultural economist—visited New France and left us with an account of the production and use of spruce beer. He noted that it was the only drink besides imported wine that the French drank.

> *After having put the cuttings of the pine into the water, they lay some of the cones of the tree amongst it, for the gum which is contained in them, is thought very wholesom[e]; and makes the beer better. The French do not cut the branches and leaves of the pine nearly so fine as the Dutch, for if the branches are small enough to go into the copper, they do no more to them, and they measure the quantity no otherwise than by putting them into the copper, till they come even with the surface of the water. While it is boiling they take some wheat, put it into the pan over the fire, and roast it as we do coffee; till it is almost black; all the while stirring, shaking, and turning it about in the pan, when that is done they throw it into the copper with some burnt bread.*
>
> *Rye is as fit for this purpose as wheat; barley is better than either, and Indian corn is better than barley. The reasons given me for putting this burnt corn and bread into the water are 1st, and chiefly to give it a brownish colour like malt liquor; 2nd to make it more palatable; 3rd, to make it something more nourishing.*
>
> *When it has continued boiling till half the quantity only of the water remains in the copper, the pine is taken out and thrown away, and the liquor is poured into a vessel, thro' a sieve of hair cloth, to prevent the burnt bread and corn from mixing with it. Then some sirrup [sic] is put into the wort to make it more palatable, and to take away the taste, which the gum of the tree might leave behind. The wort is then left to cool after some yeast has been put into it, and nothing remains to be done until it is tunned up, but skimming of what, during fermentation, has risen up upon the surface; and in four and twenty hours it is fit to drink.*

What seems to be a type of a beer beverage was called *bouillon*, but it was not the traditional beef stock. This was a common drink in Picardy and Normandy in the eighteenth century and was considered similar to Turkish beer. According to *Dictionnaire de Trévoux* (1771), it was "made from raw leaven dough, cooked in water and then after it became stale and dry was molded into the size of an egg and was thrown into the drinking pot." The fermentation of the dough must have alcoholized the drink somewhat. There is no indication in the records that this drink became popular in the Upper Peninsula among the French, whose origins would have been in these provinces.

When the French settled the Upper Peninsula, this type of beer making was known to all of the Frenchmen and the ingredients were readily available in modified form. It is interesting to note that the Ojibwe around Lake Superior made teas of wintergreen, raspberry, spruce and snowberry leaves as well as cherry twigs. However, from communications with modern Ojibwe, they did not develop spruce beer making, although they had the ingredients: spruce tips, maple sugar, water and yeast. While they did not develop the technique, spruce beer was used by the Lake Superior Ojibwe. In 1860, Johann Kohl reported that spruce beer was used by the Lake Superior Ojibwe: "They also refreshed us with a peculiar forest drink, which they honored with the name of beer…The Indians who probably invented it, called it, very prosaically, by its right name *jingobabo* or "fir branch water." This is also the name that they gave to common beer as well. Despite Kohl's comment, the making of spruce beer never became a common activity of the Native Americans in the Upper Peninsula.

The Jesuits who had missions at Sault Ste. Marie and St. Ignace, and later a chapel at Fort Michilimackinac, had the means and desire to make spruce beer. However, none of their reports even hint at brewing at these missions. By 1700, they would be in harsh confrontations with French authorities over the trade of brandy to the Native Americans, so the Jesuits did not necessarily have the desire to engage in beer making, but that is debatable.

The fur traders and soldiers at Forts Buade and Michilimackinac were capable of making spruce beer since they came from a culture where it was commonly consumed. The closest brewery to the Upper Peninsula was located at Fort Pontchartrain in Detroit, where, in 1706, Governor Antoine Cadillac hired a brewer from Montréal to produce beer for the colonists for three years.

As historian Timothy Kent has written, "*Eau-de-vie* (brandy) distilled from wine, was by far the most common alcoholic beverage that was consumed in the interior during the French era." In March 1711, Governor Marquis

Vaudreuil issued orders for voyageurs going west: "In view of the somewhat [early] season and the coldness of the water, each voyageur shall be permitted to take 4 pots [6½ quarts of brandy] to drink on the journey, on the condition that they do not give any to the natives." It was felt that stronger alcoholic beverages provided considerable lift to voyageurs and soldiers during the long journey. Beer imported from Québec City was never a real choice.

Since spruce beer was commonly consumed in the St. Lawrence valley settlements, it was natural that it followed the French to the Upper Peninsula. It was a medical necessity during the long winters when the diet of dried peas, potatoes and salt meat and a lack of vitamin C caused scurvy. This beer was made as a cottage industry, since the French at Fort Michilmackinac saw it as an infallible cure for scurvy. Unfortunately, French records say little about the production and consumption of spruce beer, but this might be due to the fact that it was so commonly used that writers saw little need to write about it.

Spruce beer was common in Canada and made from red or black spruce. A 1757 Canadian recipe follows: "It is made of the tops and branches of the spruces-tree, boiled for three hours, then strained into cask, with a certain quality of molasses; and, as soon as cold, it is fit for use."

Spruce contains vitamin C, as do other evergreens, and it was readily available in North America in fresh supply. Hops were difficult to come by, having to be imported, and molasses was readily available from France's sugar islands in the Caribbean and was cheap. Maple sugar could be used in the Upper Peninsula. It was conveniently similar to barley malts, which contain large amounts of fermentable sugar, and it did not need to be boiled to activate the sugars. Spruce beer was an ideal beverage on the far frontier of the Upper Peninsula.

THE BRITISH ERA

The end of the French and Indian War in 1760 gave the British control of the lands of New France, and as a result, the Upper Peninsula became part of the British Empire. The British established a brewery at Fort Pitt (modern Pittsburgh), which was the first brewery west of the Allegheny Mountains. At the same time, a brewery was built in Kaskaskia, Illinois, the first one established outside of the thirteen colonies.

John Porteous, writing in 1767 from Fort Michilimackinac, noted that there were three or four kinds of spruce trees, of which only one was

best for making spruce beer on the continent, and it was only equaled in Newfoundland. Within two years, spruce beer had "become the most usual table drink in all our provinces, being first brot [brought] into practice in the army by Gen. Amherst in some of his Campaigns" during the recent French and Indian War.

Dr. Daniel Morison, the British surgeon's mate stationed at Fort Michilimackinac between 1769 and 1772, has left an insightful account of the use of alcohol at the fort. The officers and men felt that they were in a "remote corner" of the world and their "principal amusement" was drinking. They had punches and toddies and parties lasting until dawn, but since rum by the barrel was so readily available, there is practically no mention of beer. The use of hard liquor led to a long list of violent encounters and court martials among the soldiers. However, on Sunday, December 9, 1770, Morison noted that Sergeant Thomas Carlile, while on duty, decided that since everyone was at church, he would slip into his home (which was close by) and quench his thirst with a cup of spruce beer, which he did.

We learn from Peter Pond's memoirs that wooden barrels of beer were delivered by a trading schooner to Fort Michilimackinac in 1773. What arrived was a non-fizzy infusion of malted barley that was meant to be drunk at room temperature. Warm fermentation created the taste and mouth-feel of ale, but the bubbles of carbon dioxide generated in the process escaped long before the drinks arrived in northern Michigan. This beverage would not have disappointed any British soldiers or traders who tasted it, as it was similar to brews served in taverns throughout the British Empire at the time. Unpressurized "real ale" made up the majority of beer brewed in Britain until only a few decades ago, and it is still sold today.

The British merchant John Askin, who resided at Fort Michilimackinac in 1777–78, provides us with some insights to the status of the beverages available to his family during the winter and the disruptive American Revolution. He noted that by late April 1778, they had some tea and sugar that his wife used "and will be able to hold out." The rest of the family drank chocolate for breakfast, and a barley substitute replaced their afternoon coffee. Spirits—rum and spruce beer—were readily available, but they would have to forego wine for the time being. Askin makes no further mention of his source of spruce beer, probably because it was readily available and he did not have to discuss the source.

In the 1780s, John Long, a British trader who served on and off as a volunteer during the American Revolution, lived in an Indian village to the west of the fort at Chippeway Point on Mackinac Island. He recounted an

incident that indicates that hogsheads of bottled beer were imported to Fort Mackinac from Detroit. At one point, Long purchased an empty hogshead (which would hold sixty-three gallons), loaded an Indian woman into it and then planned to roll it into the fort. When the hogshead arrived at the gate, it was met by the commander and commissary, who were satisfied that the garrison would have plenty of good beer to drink. Suddenly the barrel got loose and rolled to the bottom of the hill, and the imprisoned female came out, much to the surprise of the officers. At this time, bottled porter would have been quite a luxury at the fort.

Beer could never compete with the ocean of rum that entered the Upper Peninsula. Between June 1780 and 1781, 1,809 gallons of rum entered Fort Mackinac for Indian trading purposes and for the soldiers. At that time, it was British army policy to give the men a gill (½ cup) of rum per day in lieu of pay. Over the years, there was talk of substituting beer for rum for the soldiers.

The idea of a beer substitution continued in the British army and was focused on the garrison at Fort Collier on Drummond Island, the last British military post on American soil. In March 1826, Peter Turquand, commissary general at Québec City, called for substituting "porter or good strong wholesome Beer for the soldiers Ration of Rum in the proportion of one pint of the former for the present allowance of one sixth of a Quart of the latter." The beer could be provided by a brewery at Amherstburg, Ontario, opposite Detroit, without difficulty and at a lower cost. Turquand concluded that the men would have access to "good wholesome strong Beer" and this military demand would aid the development of the brewing trade. However, during the winter, when ice blocked ship passage, they would revert to rum.

On the American scene, Benjamin Franklin, who was ambassador to France from 1776 to 1785, became interested in spruce beer while in Paris. Fortunately, he has left us with a recipe entitled "Ways of Making Beer with Essence of Spruce":

> *For a Cask containing 80 bottles, take one pot of Essence and 13 Pounds of Molases.—or the same amount of unrefined Loaf Sugar; mix them well together in 20 pints of hot Water: Stir together until they make a Foam, then pour it into the Cask you will then fill with Water: add a Pint of good Yeast, stir it well together and let it stand 2 or 3 Days to ferment, after which close the Cask, and after a few days it will be ready to be put into Bottles, that must be tightly corked. Leave them 10 or 12 Days in a cool Cellar, after which the Beer will be good to drink.*

Although Ambassador Franklin never visited the Upper Peninsula, he was obviously fascinated with spruce beer, as it had become popular in France and had been popular in the colonies for decades.

J. Hector St. John de Crèvecoeur, born in Québec, wrote about beer in the colonies in his work *Letters from an American Farmer and Sketches of Eighteenth-Century America*, published in 1781:

> *Some families excel in the method of brewing beer with a strange variety of ingredients. Here we commonly make it with pine chips, pine buds, hemlock, fir leaves, roasted corn, dried apple-skins, sassafras roots, and bran. With these, to which we add some hops and a little malt, we compose a sort of beverage which is very pleasant. What most people call health-beer (which is made every spring) would greatly astonish you. I think in the last we made we had no less than seventeen ingredients.*

An American recipe from Amelia Simmon's *American Cookery* (1796) states:

> *Take four ounces of hops, let them boil half an hour in one gallon of water, strain the hop water then add sixteen gallons of warm water, two gallons of molasses, eight ounces of essence of spruce, dissolved in one quart of water, put it in a clean cask, then shake it well together, add half a pint of emptins, then let it stand and work one week, if very warm weather less time will do, when it is drawn off to bottle, add one spoonful of molasses to every bottle.*

Once the English departed from the Upper Peninsula, after turning over the region to the United States, there is no mention of spruce beer being made in the eastern Upper Peninsula. Johann Kohl, who visited the region in 1855, encountered an Irish spruce beer maker in a clearing in central Copper Country. The female brewster, who originally lived in Newfoundland, a center of spruce beer, said that she made the best beer in the area, and people paid extra for her brew. According to Kohl, she went into detail about making spruce beer but refused to give him permission to publish the recipe and process, which, unfortunately for us, he agreed to. This seems to be the only account of a settler in the Upper Peninsula making spruce beer. A number of cookbooks, going back to 1819, carry spruce beer recipes.

Today, individuals, like James Shefchik of Marquette, make it in their homes, while some UP brewers, like the Vierling's Marquette Harbor Brewery, make it on a seasonal basis. At Fort Michilimackinac, Jeff Pavlik,

a full-time baker from Farmington Hills in the Lower Peninsula, frequently travels to the fort to make bread in the outdoor oven and make a batch of spruce beer as part of their living history program, but the drink is not available to visitors. The tradition of spruce beer persists over the centuries. Thus, the oldest beer tradition in the Upper Peninsula continues its two-hundred-year history, primarily as a cottage industry. The heyday of Upper Peninsula brewing was yet to arrive.

3
BEER TO 1840

During these early years, the question of brewing and the consumption of beer is rather muted in the record. The reasons for this were the small population living in the region and the economically dominant fur trade. The fur trade was predicated on trade in brandy, rum and whiskey. As a result, there was little demand for beer, as high spirits were readily available for trade and recreational consumption and in large quantities.

The American Fur Company continued the fur trade tradition into the 1840s and also focused on beer entering the upper Great Lakes country. Established in 1808 by John Jacob Astor, its Midwest center was on Mackinac Island with branches at Sault Ste. Marie and La Pointe (modern Ashland, Wisconsin). Detroit was its major provisioning center. The American Fur Company shipped hundreds of gallons of whiskey for the Indian trade. However, by this time, beer being produced in Detroit could easily be shipped north. According to an ad in the *Cleveland Herald*, beer was being shipped from Detroit in 1829, and in 1837, there were two breweries— Detroit Brewery and City Brewery—in Detroit.

Although there is no record of beer shipped to American Fur Company outposts, it is possible that it was shipped to its stores for employee consumption. Because it had to compete with whiskey and rum, it certainly never became a trade item with the Native Americans, as whiskey and "high wine," or pure alcohol, were in great demand. At times in the 1830s, when beer was not available, cider was shipped north from Detroit to Mackinac Island. By the 1840s, there were three breweries in Detroit producing ale,

porter and "strong" beer. Later, "superior amber and brown ales" were in production. This early beer production was the main source of beer for the Upper Peninsula until the advent of German brewers and local production, beginning in 1850.

Prior to the arrival of German brewers, American breweries largely produced ales that tended to be darkly colored with a strong flavor. By the 1840s, German immigrants began to arrive in large numbers and produced lagers rather than ales. These lagers were described as being "a cleaner, crisper beverage" than ale. By 1860, most of the brewers in Detroit were Germans, and this trend followed in the Upper Peninsula. Beer historian Peter H. Blum, in *Brewed in Detroit*, has noted that the "golden age" for brewers in the United States was from 1890 to 1910.

Beer had a bit of its own history at the three military posts in the Upper Peninsula—Fort Mackinac on Mackinac Island, Fort Brady at Sault Ste. Marie and Fort Wilkins at Copper Harbor—that were in operation during those years. The United States Army saw beer as a healthy and recreational drink. It was seen as a viable alternative to hard spirits, which led to fights, alcoholism and trips to jail.

Dr. William Beaumont was a surgeon in the United States Army and became known as the "Father of Gastric Physiology" following his research on human digestion. He served in the army during the War of 1812, later rejoined in 1819 and was stationed at Fort Mackinac. At the frontier post, Dr. Beaumont was physician-pharmacist, and he developed a hospital garden, where he planted seeds of medicinal plants and ornamental flowers that were used in his practice. At one point, he attempted to grow hops for use in a beverage for convalescing patients. Obviously, this unspecified beverage was a member of the beer family and would provide nourishment for his patients.

The army's use of beer was a common but controlled practice, usually authorized by the commanding officer. The beer would have come from Hamtramck Brewery, Hawley & Company Brewers or others in Detroit or Milwaukee. It is interesting to highlight that there was a continuous history of beer being shipped to and consumed in the Upper Peninsula even in the years prior to the boom in population following the discovery of the copper and iron and opening of the mines.

For instance, on June 17, 1844, at Fort Wilkins, commanding Captain Robert E. Clary gave permission that allowed non-commissioned officers and privates:

To draw from the Sutler daily but one quart of Beer to be issued in two equal portions at separate times. The first portion to be issued immediately after recall at 12½ o'clock M., and the second portion immediately after recall in the evening. The Sutler's Store will be opened on Sundays for no other purpose than the issuing of the Beer to the Command and this to be done at the time above mentioned.

In the fall of 1844, fifty barrels of beer were sent from Detroit to Fort Wilkins by way of the American Fur Company agent at Sault Ste. Marie to last the garrison through the winter.

At Fort Mackinac in 1889, one of the oldest structures on the grounds was converted into a post canteen. This was part of army-wide reforms of the time to aid soldiers' health and recreation. In the canteen, soldiers could relax, snack, enjoy games with their friends and have a drink. The Fort Mackinac canteen featured two billiard rooms, a lunch counter, magazines and books, tables for cards and other games and, most importantly, a bar serving beer (Schlitz) and wine. This canteen kept them on the post and away from downtown saloons with their whiskey and other hard liquors, which caused drunkenness, fights and trips to the guardhouse. This early use of beer on the frontier was quickly replaced with the development of the UP's natural resources and the coming of German immigrants in the 1840s and 1850s.

4

THE GOLDEN AGE OF BREWING AND BEYOND

As the 1840s progressed, there was a change in the economy and settlement of the Upper Peninsula, which moved away from the fur trade and the military, and this had a major impact on brewing. The state geologist, Douglass Houghton, spent his summers conducting fieldwork in the northern Upper Peninsula and, in 1841, announced his discovery of large deposits of copper, triggering the first major mining boom in the United States. In the fall of 1844, William Burt discovered iron ore in the central Upper Peninsula. News of these mineral discoveries spread like wildfire through the United States and Europe. Quickly, Cornish from Britain, French Canadians, Irish and Germans joined Americans. The brewing tradition in the Upper Peninsula had arrived.

Spruce beer was quickly surpassed by German beer. The Irish became the saloonkeepers, and the Germans brought the art of brewing.

The first German brewers in the Upper Peninsula were Nickolas Voelker, Joseph Clemens and Nickolas Ritz, who arrived in the UP in the late 1840s. Voelker and his wife—Catherine, also a German immigrant—first went to the mining community of Eagle River but, two years later, resettled in Sault Ste. Marie (often called the Soo). The Soo had attracted over two dozen Germans. The Voelkers had two German boarders, Joseph Clemens and Nickolas Ritz, living with them. The three men established a small brewery, whose name is lost to time, valued at $1,000. In late June 1850, Voelker and Clemens advertised in the *Lake Superior Journal* that they were operating a brewery and

BREWRY.

The Subscribers having established themselves in the above business at Saut Ste. Marie, would respectfully in form the Inhabitants of the surrounding country that they will furnish them with all articles in their line as good and on as reasonable terms as can be purchased elsewhere.

➢ Persons are invited to give us a call before going elsewhere. VOELKER & CLEMENZ.
Saut Ste. Marie, June 26, 1850

Reproduction of the first beer ad in the Upper Peninsula in the *Lake Superior Journal. Courtesy* Sault Ste. Marie Lake Superior Journal.

"would respectfully inform the Inhabitants of the surrounding country that they will furnish them with all articles in their line as good and on as reasonable terms as can be purchased elsewhere." We do not know anything about the quality of their product, but this brewery was the first local competition for the Detroit and Milwaukee brewers. The brewery was successfully operated for a half dozen years until Voelker and Clemens decided to move to Ontonagon and Eagle River in the Copper Country to join the mining boom.

With the opening of the copper mines, the center of economic and social activity shifted to the Copper Country in the western Upper Peninsula—Eagle River, Ontonagon, Houghton—which attracted a growing number of immigrants. The Copper Country became the location for the greatest number of breweries prior to Prohibition. By 1860, the demand for miners and laborers working in the copper mines brought the population to over 7,282, with some 20 percent of this number being German immigrants. German brewers quickly realized that they could meet the demand of thirsty workers. Frank Knivel, an immigrant from Prussia, opened the Eagle River Brewery in 1855, with a capacity of 1,200 barrels annually, and successfully brewed until 1910. Joseph Clemens opened a brewery at the same time with a similar capacity. At Hancock, William Ault opened the Union Brewery in 1857, and it stayed in business until 1894. Adam Haas got into business in 1859 in Houghton, and the Haas brewery operated in various locations until 1952. In 1860, Voelker was successfully brewing beer at Ontonagon County and was assisted by John Walbrown, a Prussian, and Michael Gitzow, a teenager from Ohio. To the north at Houghton, William Holt was another Prussian brewer. He was assisted by six Prussian laborers. Aiding these breweries was the importation of malt from Detroit, which, in 1859, amounted to over twelve tons along with 1,120 barrels of liquor and beer to meet demands not satisfied by local breweries.

DEMAND FOR BEER AND SALOONS

On the mining frontier, as historian Larry Lankton wrote, "imbibing alcohol became commonplace in conjunction with sports and games, holidays, elections, paydays, and long winters infected with cabin fever." Liquor and beer were readily available in the numerous stores, hotel bars, main-street saloons and scrub taverns that crisscrossed the countryside. Beer was always available. It could be shipped in, as in October 1846, when four barrels of beer arrived from a Detroit brewery. By the 1850s, numerous breweries opened, beginning with Frank Knivel's brewery, which opened in Eagle River in 1855. From this point on, beer was available in abundance.

By the first decade of the 1860s, we learn about the role of saloons and the use of hard liquor but especially the role of beer drinking as a form amusement. As reported in the April 15, 1861 issue of the *Philadelphia Inquirer*: "In the evening the dance-houses and beer shops receive their usual number of callers, and the stereotype fights occur, tho it is very seldom that any of these little 'pleasantries' result seriously." On festive occasions, the team of miners that was able to drill the deepest the quickest won a barrel of

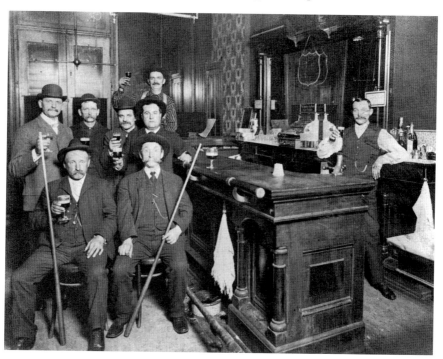

Pool sharks have refreshment between games in the Copper Country. *Courtesy Superior Views.*

beer. Within four years of its foundation, which occurred in 1863, Hancock had six thriving saloons. Henry Hobart, although not a beer drinker, has insightful observations concerning beer consumption in 1863–64. He felt that "men who are unable to read & write and who are born with a natural love for the beer and whiskey are very easily influenced to vote for certain parties or those who are liberal with a 'drop of the critter.'" After an election, the men celebrated with a mug of ale and a smoke from their pipes and everyone was "well soaked before morning." On Saturday night, mining captains would treat the men "with plenty of beer or to use the name that it goes by here, 'a drop or quert of cabbage.'" On payday, Hobart reported, "This is a jolly day among miners as they generally go and visit some beer shop and enjoy a 'drop of beer.' Very many will return to their homes beastly drunk." The Fourth of July was celebrated with "many sad and disgusting scenes especially where 'Paddy's eye water' is plenty and beer by the half barrel or as a Cornishman would prefer by the quert or bloody drop." In 1870, a Methodist minister wrote on the rough stagecoach ride from Hancock to Eagle River that the coachmen "treat their passengers at every little log tavern where they stopped to water their horses and quench their own thirst."

Given the number of immigrants who worked hard in the mines and enjoyed their beer, it is natural that Upper Peninsula communities had large numbers of saloons and resulting breweries. A review of the *Michigan State Gazetteer and Business Directory* for the year 1877 shows this. The small mining community of Rockland, with a population of 1,000, had a brewery. Calumet, with 4,000 people, had twenty-four saloons, while Lake Linden immediately to the east, with 600 people, had a brewery and seven saloons, meaning they had one saloon per 85 people. Eagle River, with 250 people, had a brewery and three saloons.

The consumption of alcohol was a constant problem for the mining bosses, as they were concerned about the negative nature of beer and hard liquor. They were joined by temperance societies and even the military to curb the consumption of alcohol, with varying success. In some areas, they sought to keep saloons out. At Quincy Hill, the Quincy Mining Company bought up all of the property in order to keep saloons out. However, one of the future bar keepers found a loophole in the property ownership and was soon in business on a small plot of land. Drunken, disorderly or violent men were fired, put off the property or had fines and damages withheld from their pay. Some men, realizing their addiction to alcohol, paid the fine in advance.

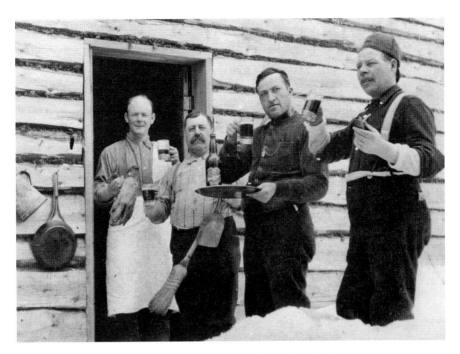

Loggers enjoying a brew on their day off at camp. *Courtesy Superior Views.*

The mining community of Michigamme in the central region had a population of one thousand souls and six saloons; neighboring Republic had a similar population and eight saloons. The thirst had to be quenched.

Away from the mining areas, the situation was similar in lumber mill communities. Escanaba, with 2,500 people had one saloon per 178 people, while Menominee had eleven saloons, averaging one saloon for every 272 people. These figures were similar throughout the area and show that the demand for beer and whiskey was great. As the years passed and the population increased, so did the growing number of saloons and breweries. By the 1880s, the western Upper Peninsula was served by eight breweries adjacent to the centers of population. Further, we are not talking about the beer that was imported from Detroit, Chicago, Milwaukee or St. Louis; it was brewed in the UP.

The early UP breweries provided enough beer for the population through the 1860s, but then copper mining greatly expanded with the opening of the Calumet and Hecla Mining Company. This coincided with the coming of thousands of immigrant laborers in the Copper Country. An early brewer to the area was Franz Hahn, who was born in Prussia in 1824, came to

the United States in 1853 and settled in Eagle River. After two years, he traveled to Milwaukee, where he learned brewing, and then returned to Eagle River, where he joined Joseph Clemens to open a brewery. In 1859, he sold out and moved to Houghton, where he worked with William Ault of the Union Brewery for two years. Next he rented a brewery with his brother and conducted business until their brewery burned down in July 1873. They immediately rebuilt a stone brewery, which had a working capacity of ten thousand barrels per year, making it one of the largest in the Upper Peninsula. Unfortunately, before they could realize success, financial losses—due to the lasting effects of the panic of 1873 and the fire—hit them.

The Houghton Bottle Beer Brewery was established by Henry Hofen around 1876 and was the first of its kind in the region. By the 1880s, approximately eight hundred barrels of beer were made and bottled annually. Franz Hahn was the manager. Little is known about the further existence of this brewery.

To the south of Houghton at Rockland, a mining village of one thousand people in 1874–75 supported the Biggi and Kelley Brewery. A number of these early breweries were quickly overwhelmed by larger and more efficient operations that dominated the market.

Another pioneer brewery in the Copper Country with an elongated history was the Union Brewery, established in 1857 by William Ault and located a mile west of Houghton on the Portage Canal. With the death of Ault in 1863, the brewery was sold to Philip Scheuermann, Frank Maywood and Adam Youngman. Scheuermann bought out his partners in the early 1870s, made improvements to the plant and renamed the brewery Phil Scheuermann Brewing Company. The brewery produced a fine beer because of the excellent spring water found on the company's site. After Scheuermann's death in 1898, the brewery was sold to the Bosch Brewing Company and became known as the Scheuermann Branch of the Bosch Brewing Company, although in many directories it appears as a separate brewery.

The company's main brands were: Rheingold, Royal Brew, Rheingold porter and a malt tonic. Their motto was "the beer that pleases." In a 1914 advertisement, it promoted its Rheingold beer as "the beer that is a liquid Food, is perfectly fermented, fully matured and made and handled under conditions of perfect cleanliness." Between 1900 and 1915, the Copper Range Railroad moved a half dozen Scheuermann boxcars around the Copper Country and east to Ishpeming. The brewery also maintained distribution branches in Hancock, Calumet and South Range.

State prohibition in 1918 put an end to the brewery. Its brewmaster at the time was Paul Nagell. When repeal came in 1933, the Bosch Brewing Company of Lake Linden moved its main operation to the former Scheuermann branch facility, and the Scheuermann name passed from the scene.

An early brewery in Houghton whose memory was lost over time was the Haun Brewery. It was opened in 1858 by George, Frank and probably Albert Haun in a structure made of native rock that was built close to the courthouse with the brewery's distinctive towering smokestack. The brewery existed for a short time and then was absorbed by Haas. George, the eldest brother, later became the agent for the Val Blatz beer agency in Hancock.

A. Haas Brewing Company

The A. Haas Brewing Company was one of the major exceptions and dominated the market for decades both before and after Prohibition. Adam Haas (1822–1878) was born in Bavaria and started his career as a cabinetmaker. When he was thirty years old, he immigrated to the United States and settled at Houghton, where he operated a boat service and engaged in the wine and liquor trade. In 1859, he built the first brewery in Houghton, which was a log structure, and began operation with a ten-barrel copper kettle that produced porter and lager beer, which he distributed locally. As the demand for his beer grew, he made additions to the original structure. By 1875, he bought the Hahn brewery and now had a capacity of six thousand barrels per year. This rose to twenty-five thousand barrels annually soon after 1900. Adam proved to be a successful businessman and landowner who also served in various public offices in Houghton County.

Soon after Adam's death in 1878, the A. Haas Brewing Company was organized and included his widow, Eva; his sons; and his daughters. Joseph served as president and Adolph as vice-president and collector. His four daughters served on the board. In 1890, the brewery was producing lager and Bohemian beer and "XXX ales."

In August 1901, the business, including the good name, was sold to a stock company composed of local businessmen. The president was Joseph Strobel; the vice-president was Michael Messner; and the secretary, treasurer and manager was William F. Miller. Miller was born in Hancock in 1865 to German immigrant parents. He had been trained as an accountant and was familiar with brewing and now oversaw about fifty men and a flourishing

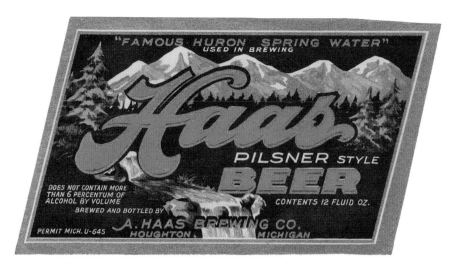

Haas beer flourished for nearly a century in the Copper Country. *Courtesy of Brian Stechschulte.*

business. Its porter and lager beers were sold throughout the Copper Country. In a matter of fifty years, the Haas brewery had made significant strides in providing beer to the local market.

The development of Haas beer bottles goes back to 1880 when they used hand-blown glass bottles, originally manufactured by the DeSteiger Glass Company in La Salle, Illinois. It was not until 1915 that they began to use machine-made bottles featuring paper labels. It was also around this time that they went from in-house advertising in the local newspapers with small ads to hiring slick Chicago agencies to advertise their beer. In its last year of operating prior to prohibition, Joseph Stroebel was president and Peter Moeller was the brewmaster. The brewery's existence and success came to an abrupt end in 1918 with the imposition of state prohibition.

The A. Haas Brewing Company was reactivated when the new board of Directors—Harry Cohodas, John F. Matte and Napoleon J. Brodeur—met on June 8, 1933, thus reopening the brewery. The Haas property was purchased from Benjamin D. Miller, stock was issued at a total of $51,900 and new brewing equipment was ordered and installed.

The new post-Prohibition Haas Brewery was reopened at its original location in Houghton on August 21, 1933. In the summer of 1934, they added new equipment and a Witteman saturator to improve carbonation and maintain a good head on the beer. They also began rebuilding, remodeling and reequipping the plant. By October 1937, it was one of the

most modern breweries in northern Michigan. It was the first brewery in the Upper Peninsula to introduce new equipment to produce canned beer. By the late 1930s, the brewery employed thirty-one full-time employees, and its fleet of six trucks served the Upper Peninsula and neighboring Wisconsin. The Haas Company remained in Houghton for about eight years before moving to Hancock to the facilities of the former Park Brewing Company, which Haas purchased in December 1941.

The company strived to live up to the brewer's motto "to give the people the finest glass of beer they can drink, regardless of cost." They used Huron spring water and the finest ingredients. During these pre–World War II years as the Haas Brewery was developing, they had numerous ads in the *Houghton Daily Mining Gazette* promoting their beers. In 1933, their two "famous brands" were Special Brew and Bavarian, advertised as "both full legal strength and fully aged," for the following prices: twenty-four twelve-ounce bottles cost $1.80, twenty-four fifteen-ounce bottles cost $2 and twelve thirty-ounce bottles cost $2. Their ads promoted beer for camping: "Vacation days are happy days if your camping supplies include Haas Beer." In 1941, they promoted their beer as "the finest drink you can get for that in-between-meal pickup or for that evening spent at home."

Over the years, the Haas Brewery produced a variety of beers made with "famous Huron spring water used in the brewery" in an attempt to appeal to different tastes. Between 1933 and 1942, their standard beers were: Extra Pale Beer, Haas Bock, and Haas Beer, and between 1933 and 1939, they had their seasonal Haas Holiday Beer. Beginning in 1942, they brewed Extra Pale Beer and Haas Beer, which lasted until 1953. Schnitt's Beer was produced beginning in 1950 and Extra Pale Beer, known as Copper Club, in 1951.

Competition from local and national brewers in Milwaukee and St. Louis was tough in this operation. The Haas name was kept until 1952 when the name was changed to the Copper Country Brewing Company. Despite these innovations and new beers, the brewery could not profitably compete and, in 1954, closed its doors for the last time, ending a ninety-five year history of the brewery.

After it closed, there was hope that the brewery would reopen, as its product had become famous throughout the western Upper Peninsula. Finally, in the spring of 1956, that hope was dashed when Cohodas officially announced that all of the machinery in the brewery would be sold.

Bosch Brewing Company

The longest lasting and largest brewery in the Copper Country was the Bosch Brewing Company. The founder of the company was Joseph Bosch, who was born in Baden, Germany, in 1850 and immigrated with his parents to the United States when he was four years of age. The family moved from New York City to Port Washington, Wisconsin, where his father engaged in brewing until 1867. Joseph learned the brewing trade and further enhanced his expertise by working at Schlitz Brewery in Milwaukee and then in breweries in Cleveland and Louisville before he moved to Lake Linden, Michigan.

In 1874, Bosch opened the Torch Lake Brewery and produced 1,717 barrels the first year. Little was sold in bottles, which came in quart size in the beginning. Beer was sold to saloons and boardinghouses, where the male head of the household was responsible for payment. By 1883, the brewery was producing 4,000 barrels of beer with 1,000 of them getting bottled. Due to the demand, the plant expanded and partners, the Wertin brothers, joined the company. The brewery used artesian well water that was known to be beneficial to those troubled with liver, kidney and stomach problems. The plant was expanded and all was going well when a terrible fire on May 20, 1887, wiped out Lake Linden and the brewery. Bosch rebuilt, and the next plant opened on September 6, much to the delight of local beer drinkers.

Between 1890 and 1895, Robert E. Foley and John F. Smith operated a general mercantile store in Eagle Harbor. They were not brewers but purchased barrels of Bosch beer and bottled the beer under their bottle label, "Foley & Smith." After 1895, they distributed Bosch beer but not under their label.

Bosch advertised in local ethnic—Croatian, Finnish, French, German, Italians and Slovenian—newspapers, sold to ethnic boardinghouses and was continuously improving his plant with new machinery and equipment. In 1889, out of 102 breweries in Michigan, Bosch Brewing Company was rated number 11 in the state behind 8 breweries in Detroit and 1 each in Grand Rapids and Muskegon. He also brought in master brewers like Melchior S. Kemp, who was trained at the United States Brewing Academy in New York City in 1895. On February 1, 1899, the old Union Brewery (established 1863), just west of Houghton, was acquired by Bosch. The site provided Bosch a second brewing location with a babbling spring and fine water as well. By this time, the brewery had thirty-five employees being paid $1.98 a day.

In February 1903, the company introduced "Malt Tonic," which was advertised as "the very essence of the most invigorating grain (barley) with

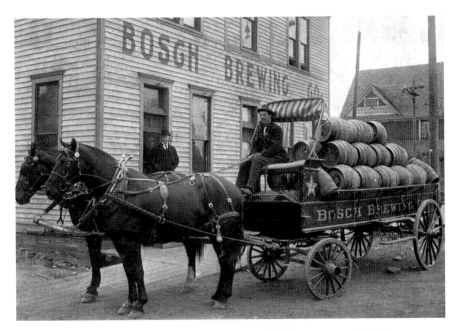

Bosch Brewing delivered beer throughout the western UP by wagon and rail. *Courtesy Superior Views.*

the soothing and beneficent extract of hops…for convalescents, for the weak and overworked, for nursing mothers and all who require a real tonic. Physicians recommend it." The ad concluded, "take a wine glass at meal time and before going to bed, it feeds blood, bone and brain."

The demand for beer continued and Bosch operated both plants in Houghton and Lake Linden, continually improved machinery and equipment and wired the plant for electrical connection. It was the largest industry in the Copper Country, after the copper mines, and had an annual capacity of fifty thousand barrels. In 1910, you could buy a case of quart bottles for one dollar. A year later, the company brought their product to Antwerp, Belgium, an important beer center, and won a gold medal and Diploma of Honor for their product.

The company at this time used rail boxcars to transport its beer throughout the Copper Country and beyond because of its fine reputation. At the time of its closing in 1918, the officers of the company were: Joseph Bosch, president; A.F. Heldkamp, secretary-treasurer; H. Reinwand, superintendent of the bottling department; and M.S. Kemp, brewmaster.

Prior to Prohibition, breweries could operate their own saloons, and Bosch opened at least two saloons to sell its beer. One was the Gilt Edge Tavern

on Shelden Street in Houghton, and the other was a tavern in the Michigan House in Calumet. In the Houghton tavern, a German artist, Franz E. Rohrbeck from Milwaukee, painted a colorful and quaint series of murals depicting German gnomes making and drinking beer and wine. The paintings are oil on canvas with a couple coats of varnish on top to preserve them.

During the dark days of Prohibition, the paintings in the Gilt Edge Tavern were removed, rolled up and placed in storage, where they remained for twelve years until alcohol was legal again. In the late 1940s or '50s, the paintings were acquired by Bernie Vandette and put up in the Ambassador Tavern in Houghton where they are on display. These are the only known taverns in the Upper Peninsula opened by a brewer and having these murals. You can return to the era of 1902 and enjoy them while you have a beer and food.

The Bosch Brewery applied for and received a license to brew from the state of Michigan soon after the end of Prohibition in 1933. The Bosch Brewery closed its Lake Linden location and focused on the Houghton plant. They created a modern facility in the remodeled Scheuermann Brewery, which became one of the most efficient breweries in the nation. A laboratory maintained a chemical check and balance to ensure quality and consistency of their product. They also used external professional brewing labs for increased control.

By 1964, the management of the brewery was under the leadership of Katherine Bosch, the granddaughter of Joseph; nephew Philip Ruppe, who

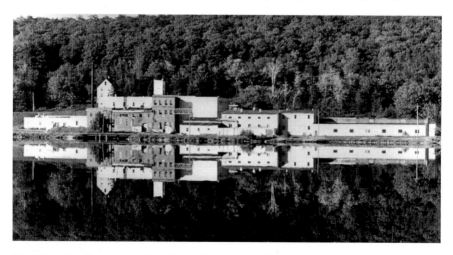

Bosch Brewing Company in Houghton after the move from Lake Linden, circa 1950. *Courtesy Superior Views.*

was president; and James Ruppe, executive vice-president. Although the plant was operating at full capacity, it had to pay Michigan beer tax, one of the highest beer taxes in the nation, and they were operating at a loss. As a result, they decided to close on August 1, 1965.

At this point, the community rallied and came together. Key executives, family, employees and townspeople sought to avert closure, which would mean the loss of jobs, tax revenue and, for consumers, the end of a quality product. Charles W. Finger of the International Union of United Brewery, Flour, Cereal Local 251 of the Malt, Yeast, Soft Drinks and Distillery Workers was the vice-president and brewmaster. If the tax could be reversed, the brewery could operate at a profit. In the past twenty years, $2 million had been invested in plant improvements, modernization, machinery replacement and strict maintenance.

By this time, sales had dropped to 61,000 barrels from an all-time high of 100,000 barrels (1955–61). Finger became president in June 1965 and negotiated with the ten stockholders. James Jeffords was appointed chief advertiser, and even Finger went on speaking engagements promoting the beer, which he noted was made with deep underground spring water and authentic brewing techniques. The brand image was promoted, and there was greater market acceptance. The new themes were: "Bright Bold Flavor," "Smooth, Mellow, Golden" and the fact that the beer was "from the Sportsman's Paradise." Beer in cans, bottles and on draught were promoted in newspapers and on television with the budgets national companies had. As a result, between 1968 and 1970, there was a sales upswing. The plan was to make it to the centennial and continue. In 1970, prior to the legislated returnable bottle law in Michigan, Bosch introduced returnable bottles. The beers promoted were Gilt Edge, Bosch Premium and the new Light Sauna Beer. The latter beer was developed in consultation with brewers in Finland and was similar to Finnish *kalja*, a popular light after-sauna beverage. This beer fits into the Finnish culture and the sauna, which are important aspects of life in the Upper Peninsula.

Unfortunately, all of this effort did not bring about increased sales. The company closed in October 1973, just a few months before its centennial anniversary. The Jacob Leinenkugel Brewing Company of Chippewa Falls, Wisconsin, purchased the Bosch Brewing Company. Bosch master brewer Vincent Charney was hired, and Leinenkugel continued to produce the signature Bosch brand with the traditional flavors. Loyal Bosch drinkers continued enjoying the product, but after a few years, profits fell. In 1985, the brand was discontinued.

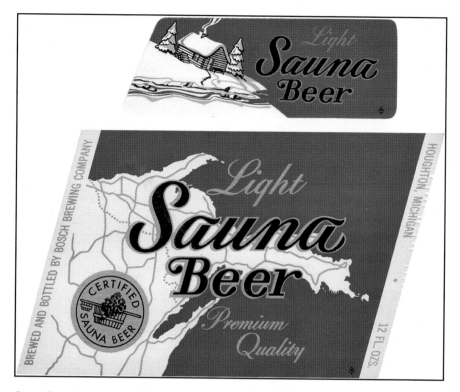

Sauna Beer fit into the local Finnish-dominated culture of the UP. *Courtesy of Brian Stechschulte.*

The latter history of Bosch fit into the decline of American breweries. After Prohibition, there were 735 breweries in the United States, but by 1960, the number had dropped to 170. A dozen years later, there were only 70 plants.

Bosch had terminated twenty years before the rise of micorbreweries. As Leinenkugel's Chuck Strehl reported in 1994, "Microbreweries have become economically feasible in past years and some small breweries have been able to get a new lease on life." He said, "The Bosch label could probably be produced today and even make a profit."

Calumet Brewing Company

M. Miswald and his brothers made a number of attempts at breweries in the Copper Country. In 1891, they opened one in L'Anse that lasted for several years. Between 1895 and 1897, they also operated a brewery in Ontonagon

to the west. Finally, they moved to Calumet and opened the Miswald Bros. & Co. Brewery in 1898, located at 509 Pine Street. They changed its name a year later to the Calumet Brewing Company.

Organized as a stock company, George Hall was president of the company and was assisted by administrators of German and Italian origin: Charles Schenck, vice-president; Frank Schrader, secretary; and G. Martini, treasurer. John Knivel of Calumet also served on the board of directors. It was the only brewery in Calumet and, as a result, all of the major population centers in the Copper Country now had their own brewery. By 1913, it employed twenty workers. Its slogan was "Pure and without drugs or poison," which tells there were bad food and drink problems at the time. Its label had an Indian's head on it and the beer was called Calumet's Pride. It also produced a Würtzburger-style beer, which was "recommended by physicians for sleeplessness, indigestion and run-down systems. To be taken in glassfuls before meals and at bedtime."

As the temperance movement was gaining strength for the fateful 1916 election, Calumet Brewing Company, along with other brewers, promoted the

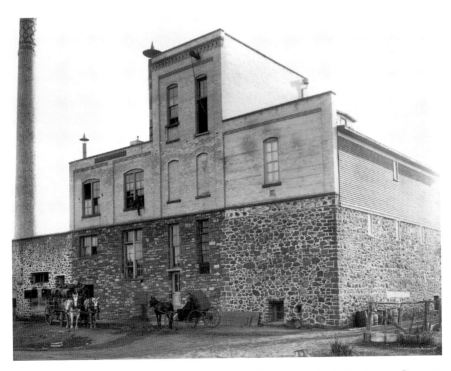

The opening of the Calumet Brewery gave every major community in the Copper Country a source of beer. *Courtesy Superior Views.*

healthful benefits of beer. The question "why is beer a food?" was answered in the following manner, "Calumet beer is a food because it contains the extract of choicest selected barley malt. That is nourishment. Calumet beer is equally as wholesome to drink as corn bread, rice pudding or barley soup are to eat on our tables. Altogether, the food value of Calumet beer amounts to about 12 percent. The balance, 88 percent, is pure water. There is much more than passing pleasure in your glass of Calumet beer. It is invigorating and healthful." In another ad, beer's healthful advantages were promoted: "Beer adds strength to both mind and muscle. It is a neutralizer to the nervous system; a builder of brawn and brain." The ad naturally concluded, "The best beer is the shortest route to these desirable advantages. The best beer for quality, flavor, wholesome and purity is CALUMET BEER."

On the eve of prohibition, the following were officers of the company: George Hall, president; Frank Schroeder, vice-president; Frank H. Shumaker, treasurer; Charles Schenck, secretary and manager; and John Wittstock, brewmaster. The brewery closed in 1918 with the advent of state prohibition. It reopened by 1920 and continued for a year with nine employees bottling soft drinks, but it did not reopen as a brewery after repeal in 1933.

Park Brewing Company, Hancock

During the boom years of the Copper Country, when copper mining was in full progress, the two main breweries—Haas and Bosch—dominated the market. However, in May 1906, a group of businessmen decided to organize the Park Brewing Company in Hancock on the southwest corner Ethel and Railroad Avenues. It was hoped that since Hancock did not have a brewery like Houghton and Lake Linden, this facility would energize the city's industrial future. Italians constituted the largest number of stockholders in the company. A large, modern facility was constructed, and production of select lager beer began. By 1909, the Park Brewing Company had ten employees. During the early years, A.J. Scott was the founder and president, along with Frank J. Voith as secretary and W.H. McGann as treasurer.

In July 1913, the members of the United Brewery Workers at Park Brewing went on strike demanding a nine-hour working day, a minimum scale of from $15 to $17 per week and a signed working agreement between the company and the workers. The management sent in strikebreakers and the brewery continued in operation. However, striking copper miners supported the brewery workers and refused to patronize saloons carrying scab beer.

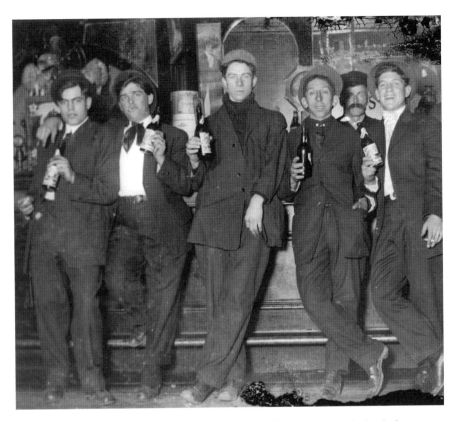

Copper Country breweries provided a variety of brews for this group enjoying its beer. *Courtesy Superior View.*

As a result, the strikers—through the intervention of Charles Nickolaus, international executive board member of the United Brewery Workers—got their demands and went back to work.

The Park Brewery successfully operated until the arrival of state prohibition in 1918, when it closed. At the time, its officers were: D.J. Norton, president; James Wignetto, vice-president; Paul H. Exley, secretary and treasurer; Michael B. Holland, general manager; Fred Parsons, manager of the bottling department; and W.J. Graf, brewmaster.

The company was reorganized, and in August 1933, the A. Villanelli Oil Company, one of the original stockholders, sold the building to several Milwaukee associates including A.E. Kops and S.C. Kops. Between $250,000 and $300,000 was spent in reconditioning the building and putting in new equipment. Villanelli remained a substantial stockholder in the new company. The brewery reopened soon after these renovations.

In its revived state, the brewery once again prospered. By 1937, its beer was found in all area hotels, taverns and nightclubs. A Park advertisement stated, "Keep a case in your home if you want to be popular with your friends." The brew was considered "as refreshing as a mountain stream." The company promoted the purchase of a barrel or keg for home use: "Park Brew in a barrel—just the right size for your requirements. It's economical to buy…and there's as much satisfaction to a draught of this mild and mellow beer as to hauling in a line with a snappy, fighting trout a-hook! It goes down mighty smooth…and you can't think of a better compliment to pay your friends than to serve them Park Brew." Other Copper Country breweries would follow this line of promoting beer in its natural Upper Peninsula setting.

Despite these ads and promotion, the Park Brewery's existence came to an end. On December 15, 1941, the Cohodas-Paoli people bought it, and the property became part of the Haas brewery.

BREWING AT L'ANSE

At the extreme southern edge of the Copper Country, to the east of Ontonagon in L'Anse, a number of attempts were made to develop and sustain breweries. The area was thriving around the early logging industry, slate quarrying, fishing and farming. Although a number of small breweries were developed in L'Anse, it is difficult to clearly separate the various breweries as separate entities or merely expansions of a previous brewery. In 1873, the Bavarian Brewery opened and Emil Meisler and Henry Steinbeck were involved with this enterprise. Then Steinbeck, John Q. McKernan and T.W. Edward were associated with the L'Anse Brewing Company, which lasted until 1878. In 1884, the Farley and Meisler Brewery opened and then became the Emil Meisler Brewery (1890–93) to be followed by the M. Miswald & Bros. Brewery, which finally closed in 1896 and ended brewing in L'Anse. Much of what we know about these breweries has come from beer bottles, which have survived and indicate that these breweries were active in 1881.

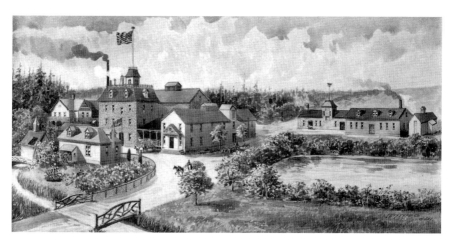

Original Upper Peninsula Brewing Company, established by George Rublein, Marquette, Michigan. *Courtesy Superior Views.*

MARQUETTE IRON RANGE

The Marquette Iron Range in the central Upper Peninsula developed a large population based around the cities of Ishpeming and Negaunee, which were major mining centers, and Marquette, the county seat and the major port for the shipment of iron ore. As a result of this development, a number of breweries were established and lasted for varying periods of time. Some of these breweries were short-lived and little information is available.

The mining town of Negaunee was never a major brewing center but had a number of small breweries in its early years. For most of them, we only have their names and years of operation: George C. Shelden Brewery (1874–75), F.A. Liebenstein Brewery (1878–79), Ferdinand Winter Brewery (1878–90), Ferdinand Winter & Son Brewery (1890–97), J.J. Kohl & Co, Brewery (1879–80), Meeske & Hoch Brewery (1880–90), and Upper Peninsula Brewing Company (1890–96).

Upper Peninsula Brewing Company

The first German brewer on the Marquette Range was George Rublein, who was born in Bavaria, Germany, in 1823. He came with his wife, Catherine, to Marquette in 1849 from Milwaukee. He purchased land on County Road 492 several miles west of Marquette, where he developed a farm growing hay and grain. He was successful, and by 1860, he had a personal estate of

$5,000. A group of family and friends from Bavaria settled in the vicinity of his farm and became successful farmers themselves.

Rublein opened the first brewery, called the Franklin Brewery, on his farm, which burned in September 1867. It was rebuilt and in operation in 1871. A year later, Rublein decided to move closer to town and reestablished the Franklin Brewery over a natural spring, which provided the brewery with a fine source of water. Rublein celebrated a grand opening in December 1873. Two years later, he added a beer or summer garden called Whiteville Elysium. It included summer homes, a hall, a music stand and ponds, which became a recreational focal point for many years three miles west of downtown Marquette. At the same time, Rublein changed the name to the Concordia Brewery. The sale of Concordia beer beginning in the summer of 1875 was not limited to the city of Marquette but was "always on hand, and delivered to any of the stations on the line of the Marquette, Houghton & Ontonagon Railroad, at the lowest cash prices."

All seemed to be going well as the brewery reached a capacity of 15,000 barrels annually. However, the lingering effects of the panic of 1873 still haunted the Upper Peninsula, and he faced stiff competition from outside brewers. As a result, the brewery was closed in early 1878, and the title to the property passed to Marquette banker Peter White. In the fall, White interested Charles Meeske and Reiner Hoch in taking over the property. These German immigrants had learned the brewing trade in Milwaukee. They agreed, leased the brewery and would purchase it if they were a success.

In May 1881, Meeske and Hoch purchased the Peninsula Brewery in Negaunee, which had been established by Nickolas Voelker and a Mr. Etty in 1869. Soon after, in 1870, Voelker and Etty sold out to George C. Shelden, who carried on for four to five years and then suspended business, probably due to the poor economy at the time. The brewery remained idle for a several years and then was purchased by Frank Leibenstein, who operated it until the Meeske-Hoch investment. Their operation was divided between Negaunee and Marquette. Hoch took over the Negaunee plant. A new malt house was constructed and had a capacity of 150,000 bushels yearly. The frame buildings were repaired and painted, and the brewery was soon producing 25,000 barrels annually. The beer was considered of the "best quality." Eventually, the two operations were combined in Marquette.

In 1882, Meeske and Hoch decided to give up the lease and purchased the Concordia Brewery. Their goal was to show that the very best quality lager could "be made on Lake Superior as anywhere else." They began to make major improvements to the original buildings in the 1890s. Brick

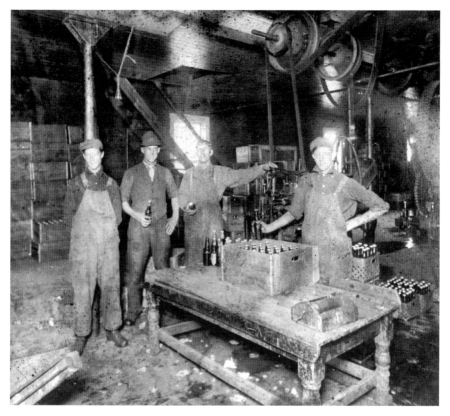

Workers capping and packing beer bottles at the Upper Peninsula Brewery, circa 1905, in Marquette, Michigan. *Courtesy Superior Views.*

and sandstone were used to create a castle-like structure, which became a Marquette landmark. The original name was changed to the Upper Peninsula Brewing Company to give the company and its product a broader appeal. Meeske had two large houses constructed for married workers, and single men boarded in the owner's home. In 1894, Meeske constructed his home and office, which survives today at the corner of Meeske Avenue and US 41. Since state law prohibited anyone from entering the brewery after sundown, Meekse constructed a tunnel that allowed him to enter the brewery without getting caught and violating the law.

By the early years of the twentieth century, the Upper Peninsula Brewing Company's facility was an architectural and brewing marvel. They produced "the beer that made Marquette famous"—Drei Kaiser, or Three Kings Beer, the label of which showed three jolly fat kings toasting with mugs held high. The brewery produced Drei-Kaiser Export and Drei-Kaiser Standard,

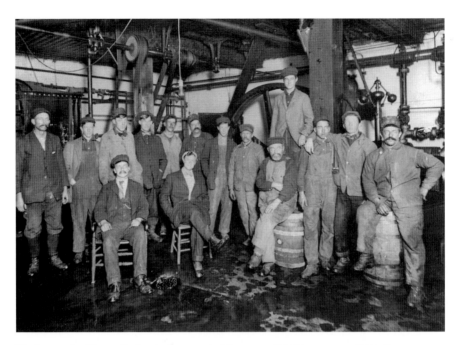

Workers at the Upper Peninsula Brewery in Marquette, Michigan, circa 1910. *Courtesy Superior Views.*

which was considered "superior to any." The beer became popular because it was considered pure and wholesome, and only the best malts and hops were used. One report stated, "The most careful chemical analysis fails to show the slightest tint of anything in the way of adulteration." Drei Kaiser was sold throughout the Upper Peninsula. The name remained in place until 1913, when it was changed to Castle Brew to reflect the architecture of the brewery.

Due to Meeske's excellent business acumen and conservative business attitude, the brewery flourished. Whether in the opening years when his plant was small or through its peak, he always produced a high-quality beer that was in great demand. In early 1918, the officers of the brewery were: Charles Meeske, president, treasurer and manager; Reiner Hoch, vice-president; Albert Heinemann, secretary; and Eugene Schaer, brewmaster. Until it closed in the spring of 1918 with the coming of state prohibition, the brewery "was one of the best appointed, as well as most attractively located, plants of its kind in the state," according to the *Mining Journal.* With prohibition, there were no plans for Meeske to reopen the plant to produce soft drinks or other types of beverages, as it "was not a plant that would lend itself to any other use."

With Michigan prohibition and the Upper Peninsula Brewing Company forced to close, Meeske moved to Duluth. Hoch had established the Duluth Brewing and Malting Company in 1896, and Meekse joined him for a short stay. By 1918, Meeske was in his late sixties and was ready to retire from the business that he had so successfully developed. The Meeskes left Marquette for San Diego, and even after the end of Prohibition in 1933, the Upper Peninsula Brewing Company never reopened. Meeske's son, Carl, became president and general manger of the Duluth Brewing and Malting Company when the plant reopened in January 1934. In a letter to the *Mining Journal*, he said that his plant would brew Castle Beer and other products using his father's formula to be sold in Marquette. At the time, there was talk that Castle Beer would be shipped in bulk and bottled in the old plant, but this did not occur. The attractive castle structure remained deserted and a photographer's focal point until the 1970s, when it was demolished for a new bank building.

Hoch & Thoney Brewers, Ishpeming and Marquette

By 1890, Henry W. Hoch and George Thoney were proprietors of the Marquette and Ishpeming Bottling Works. They manufactured "export beer, family table beer, egg soda, champagne cider, ginger ale, seltzer water, birch beer and all leading summer drinks." A bit later, Heinemann joined Hoch, and the bottling works bottled Meeske and Hoch lager beer, which was made with mineral spring water.

ESCANABA BREWERIES

Escanaba is known for lumber and fishing industries and the shipment of iron ore. Shepley and Nolden opened the first brewery in 1874 and were followed by the Joseph Nolden Brewery, which closed in 1884. Henry Rahr of the Green Bay, Wisconsin brewing dynasty arrived in Escanaba and, with the Walch brothers, made plans to construct a large facility on the 1300 block of Lake Shore Drive on the site of an artesian spring, which provided a constant supply of sparkling water. He also hoped that the local farmers would produce enough barley so that he could also open a malting plant. Construction was begun on the four-story brick castellated brewery,

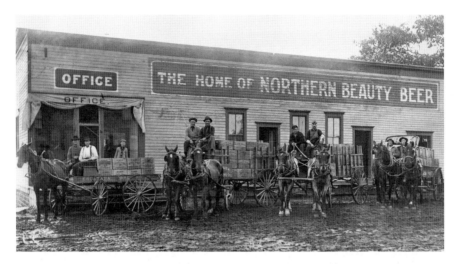

"The Home of Northern Beauty Beer," Escanaba Brewing Company, Escanaba, Michigan. *Courtesy Delta County Historical Society.*

which had a vast interior, and brewing equipment arrived in November. While construction was underway, Rahr beer from Green Bay, Schlitz from Milwaukee and Leisen and Henes beer from Menominee curbed the thirst of locals. In April 1887, the brewery opened, and its name changed to the Escanaba Brewing Company. One of the early brewmasters was John Richter, who would eventually develop his own brewery.

The brewery was a success and was known for its Northern Beauty Beer. Over the years, it took out interesting promotional ads in the local newspapers. In May 1895, the *Iron Port* carried one that pushed its bottled beer with the slogan "take no other." The ad continued, "This 'Eelicious Everage,' is bottled at the Escanaba Brewing Company's bottling works and is just what you want. All liquor dealers sell it." Over a decade later, when muckraking journalists were writing about adulterated food and drink, the *Escanaba Daily Mirror* carried: "The beer brewed by the Escanaba Brewing Company is mild, wholesome, and nutritious and is a refreshing beverage. It is prepared under conditions of utmost cleanliness and is always pure and free from adulteration. Try a case." In 1913, Old Escanaba Beer was touted as "the beer that leads them all." In early 1918, the brewery's officers included: Nicholas H. Walch, president and manager; Victor K. Blomstrom, vice-president; John N. Semer, secretary and treasurer; and Charles C. Mueller, brewmaster.

On the eve of state prohibition, the brewery began producing Neerit, a cereal beverage that is "a wholesome drink for the whole family." The

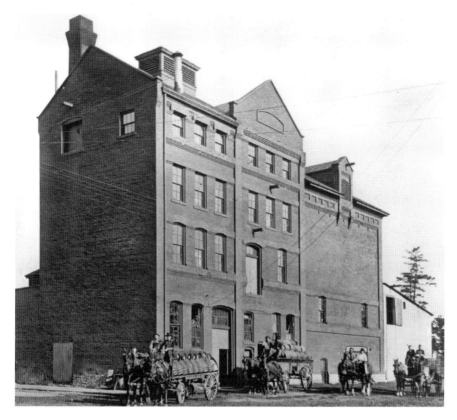

Escanaba Brewing Company, circa 1915, in Escanaba, Michigan. *Courtesy Superior Views.*

calendar advertisement it distributed continued, "easy to say—easier to drink—Neerit. Like needles are a household necessity. Drink Neerit with your meals or between meals."

Although they tried to remain in business, the operation finally closed, and the brewery was deserted. Tax problems ensued, and in 1941, the property was deeded to the city of Escanaba for recreational use. The structure was demolished, and today Veterans' Park sits on the site of the brewery.

Richter Brewing Company

John Ritcher had arrived in Escanaba in 1886 having worked at the Rahr brewery in Green Bay and other locations in Wisconsin. He was a fine brewmaster, and Escanaba Brewing Company hired him as head

brewer. He worked there for twelve years, and in the summer of 1900, he decided to develop his own brewery. In August 1900, Richter and his board incorporated the brewery with $60,000 as capital. The property was located at 1609 Ludington Street, where an artesian spring would provide a continuous supply of pure water. Within weeks, construction of the brewery began. It was a four-story Romanesque Revival–style building. To the east of the brewery was the bottling plant. Brewing equipment was immediately ordered from Vilter Manufacturing in Milwaukee, which included a twenty-five-ton ice machine and the best machinery and storage tanks available. The brewery went into operation in February 1901. In April, the first batch of beer was ready for the market. Saloons owned by stockholders of the company received the first kegs of beer and then sample kegs were sent to every saloon in Escanaba. The new brew was declared to be of excellent quality, and drinkers were "well satisfied." Richter refused to cut prices and have a beer war with Milwaukee brewers, and thus, uniform prices were maintained. When working at full capacity, the brewery produced twelve to fifteen thousand barrels of beer annually.

The Richter Brewing Company flourished during the first decades of the twentieth century. Their labels included Richter's Select and Richter's Special Beer, which were sold locally. An advertisement in the *Iron Ore* newspaper, in the fall of 1908, suggested the public "ask for Richter Beer" and continued, "There is a vim and a snap to this beer that is a sign of A1 materials and superior brewing. It affords just the proper degree of healthful stimulation needed by busy people and its effects are greatly beneficial. It makes good red blood and builds up the tissues." In another ad in the same newspaper, a strong temperance approach was taken. Overdrinking was compared to over eating, and their beer, with less than 4 percent alcohol, had less alcohol than hard cider. The ad concluded, "The alcohol contained in Richter Beer constitutes a useful part. It adds to its nutritive value, aids digestion and is altogether beneficial." This focus on the healthful benefits of beer and presenting it as a "temperance beverage" was a move to try to curb the propaganda of the Anti-Saloon League, which was pushing for national Prohibition.

On the eve of Prohibition, the officers of the company included: Richard Hoyler, president and manager; John Richter, vice-president; F.J. Defnet, secretary; and Charles Javurek, brewmaster. These individuals would see the end of one company and its revival in a different form.

On November 7, 1916, Michiganians voted for state prohibition, despite the ads over the years promoting the healthy benefits of beer. Now stockholders had the choice of closing the brewery or making changes. On

April 22, 1918, prior to prohibition going into effect, President Richard Hoyler and the stockholders held a special meeting and changed the Articles of Association. The company would become known as the Richter Beverage Company, whose purpose would be "to engage in the business of manufacturing, keeping for sale and selling non-alcoholic and unfermented beverages, soft drink and temperance beverages, and to bottle the same and to purchase and own and use any and all kinds of property and formulae necessary or incidental to the carrying on of said business."

By late April 1918, the new non-alcoholic beverage, Ricto, was on the market. It was made of pure water, the choicest cereals and had a hops flavor that gave it an aromatic taste. An ad in the *Escanaba Daily Press* concluded that Ricto was the "first choice of those who have tried it." The Richter folks promoted the idea that "as loyal citizens of a community, we should, so far as possible, make use of those things produced by our fellow workers. That is co-operation." Escanabans should buy locally and keep their money at home. The company also distributed Schlitz Near Beer and Coca Cola.

The Richter brewery (after the end of Prohibition, the Delta Brewing Company) main brew house in Escanaba, Michigan. It has been adapted to house shops and apartments. *Courtesy R.M. Magnaghi.*

The Whistle brand came in some fifteen flavors, which included mountain beer, root beer and birch beer. The company had made the successful conversion from brewing to making and selling soft drinks.

After national Prohibition in 1933, the brewery restarted and incorporated as the Delta Brewing Company. Production rose so that, by 1940, they were producing thirty thousand barrels annually. Labels for Delta Lager Beer ("the beer of the century" and "drink it—you'll enjoy it"), Delta Special ("famous for its ale base"), Peninsula Pride (of "unexcelled flavor and bouquet"), Buckingham

Ale, Hiawatha Draught ("brewed and aged in Hiawatha Land") and Arctic Club ("brewed with the finest artesian water") were found in liquor stores and taverns throughout the area.

Business did not go well for Richter. In 1938, Albert Pick, a Chicago hotel outfitter, sent Pat Hayes of Chicago north to deal with Richter's $140,000 loan. He had previously solved a Gambrinus Brewery management problem. Hayes would go on to develop the Ludington Hotel for which he became famous, but could not save Delta Brewing Company. It closed in 1940, and thus, Escanaba's twentieth-century brewing era came to a close. The former brewery building stood forlorn until Matthew Sviland decided to rescue it in 2008. It has been renovated into residential lofts and retail stores and has become an icon on Ludington Street.

Menominee's Breweries

At the southern tip of the Upper Peninsula on the Wisconsin border is Menominee, a lumber mill town with six huge mills that cut billions of board feet of timber in the late nineteenth century. The mill workers and lumberjacks—many of whom were German, Bohemian, Polish and French Canadian—came to town with a thirst for beer. A number of breweries opened, beginning in 1870, and were short lived: Louis Hartung Brewery (1870–72), De Heck and Scharmbruch Brewery (1870–?), George Harter Brewery (?–1876), Gauch and Berthold Brewery (1874–76), Adam Gauch Brewery (1874–76), Eichert and Skala Brewery (1886–87) and Skala and W. Reindl Brewery (1887–88). The Skala and Reindl Brewery developed into the Menominee River Brewing Company and lasted until prohibition. The other large brewer was Leisen and Henes, which started in 1876. With the end of prohibition in 1933, the Menominee-Marinette Brewing Company opened and lasted until 1961.

Menominee River Brewing Company

The Menominee River brewery was located on the banks of the Menominee River, which made it convenient for trading in Menominee and neighboring Marinette, across the river in Wisconsin. Mr. Eichert and Mr. Skala established the small-scale brewery in 1886. As partners, they combined their assets and

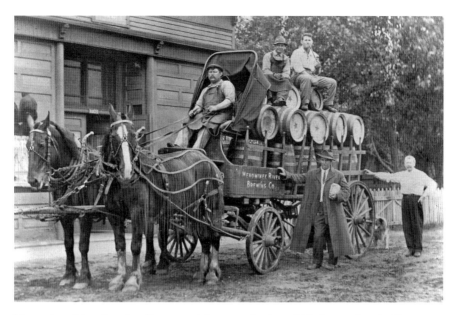

Menominee River Brewing Company delivery truck, circa 1916. *Courtesy Superior Views.*

erected the first building on site. It was a two-story frame fitted with brewing equipment for small-capacity production. In the beginning, the business slowly developed, and Eichert withdrew from the firm and disposed of his interests to Wolfgang Reindl. Under the new management, the business of the brewery was pushed to the full capacity of the plant, with the result that it soon became apparent to the proprietors that additional facilities were needed. New machinery was put in, and other essential improvements were made. However, in 1891, the additional demands for their beer convinced Reindl and Skala of the necessity of enlarging the plant. To raise the needed funds for the expansion, a stock company was organized and incorporated under the laws of the state of Michigan. Some of the stockholders were the well-known and substantial residents of the city.

The decision was made to erect a large, modern plant. Plans were immediately drawn up, and construction was begun. The board of directors directly supervised construction. The board was comprised of Wolfgang Reindl, F.C. Nowack, Franck Erdlitz, M. Bohmann, Samuel Pelier, Philip Loewenstein, Fred Maas and Gustav Weiner. The old brewery building was renovated. The buildings, yards and sheds composing the operation covered five acres. The new brewery was capitalized at $100,000 and developed the capacity of producing 120 barrels daily and had the facilities to double its production.

Between 1891 and 1894, business increased threefold. Three years later, they were advertising their beers: Golden Drop, Silver Cream, Dublin Stout and Dixie, available in quarts and pints and "always on hand." In 1907, the officers of the company were: Wolfgang Reindl, president; Michael Bohmann, vice-president; and Frank Erlitz, secretary-treasurer.

One of the leading figures in the development of the brewery was Wolfgang Reindl, who was born in Austria in 1851 and immigrated to the United States seventeen years later. He was employed as a shoemaker in Menominee until 1884, when he became involved in the brewing business. His energy and foresight led to the development of a successful operation.

In 1896, they were producing a number of brands—"Family," "Standard," "Silver"—which were available in quarts and pints. They also ran an ad that read, "Tempt your appetite by drinking a glass or two of sparkling fine flavored Menominee River Beer before and with each meal. It is a great digestion aider, too, as many former invalids have found out when they use Menominee River Beer as a mild tonic. Delivered in case lots."

By 1900, the mammoth brewery was considered one of the leading industries in Menominee-Marinette, replacing the lumber mills in that capacity. At this time, Wolfgang and his brewmaster son, John Reindl, opened a beer garden, called the Palm Garden, in Marinette. Several years later, a second beer garden, called Charlie Schale's Palm Garden, was opened in Menominee. A third beer garden operated by the Menominee River Brewery was opened right next door to the Leisen and Henes plant. All of these beer gardens were located at streetcar stops, which enhanced their business.

On the eve of prohibition, the company's officers included: Wolfgang Reindl, president; Frank Erdlitz, secretary-treasurer; Frank Brown, superintendent of bottling; and John G. Reindl, brewmaster. In 1917, prior to the implementation of prohibition, the officers of Menomine River Brewing Company and Leisen and Henes combined their plants. They formed the United Beverage Company and operated out of the Leisen and Henes plant. The grand facilities of the Menominee River Brewing Company were sold to the Menominee Rule and Block Company in July 1920.

Leisen and Henes Brewing Company

Leisen and Henes Brewing in Menominee can be traced back to 1872, when John De Heck and George Scharmbruck first opened a brewery. The following year, George Harter and Frank Eggard succeeded them. Four years

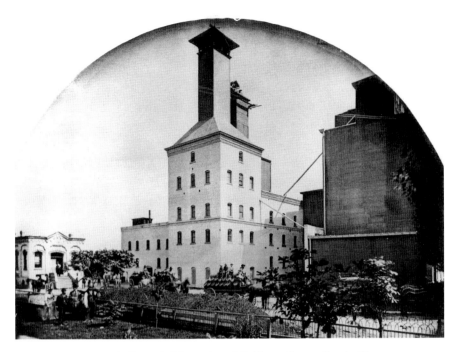

Leisen and Henes Malt House in Menominee, Michigan. *Courtesy Superior Views.*

later, the brewery passed into the hands of Jacob Leisen and John Henes, who continued the business, despite a disastrous fire in 1877.

Henes arrived in Menominee and secured the position of brewmaster in the brewery of Adam Gauch. In 1876, he become associated with his father-in-law, Jacob Leisen, in the purchase of the Gauch brewery. Later, they purchased George Harter's brewery. They conducted the business under the firm name of Leisen and Henes until 1890, when the Leisen and Henes Brewing Company was organized.

The Leisen and Henes Brewing Company had as their motto, "The Beer That Was," which quickly caught on with the drinking public. In 1896, their labels included Ideal, Braun Gold, Standard and Nuremberger. The latter beer was advertised as being "made after the same process used by our forefathers and as for its purity and age are concerned, is not outrivaled in the country." In an interesting focus, the company's ads noted its beer was "hugely recommended by physicians and judges of first-class beer as a pleasant beverage and as a health tonic."

Another fire, on June 24, 1890, forced the owners to rebuild. Then, in July 1891, the Leisen and Henes Brewing Company was incorporated under

Michigan law with capital at $100,000. At the time, Jacob Leisen was president, Louis Leisen was vice-president and John Henes was secretary-treasurer.

The plant included a stock, engine and boiler house, the bottling department, natural ice cooler, stables, offices and associated structures. The brewery was equipped with all the latest improved apparatus and appliances, and the brew kettle had a capacity of 150 barrels. The malt house had a capacity of 90,000 bushels. The storage accommodations were very complete, so that, when combined with the purity of ingredients and the skill in manufacture, the brewery had ample facilities for producing properly mature large stocks of beer. Thirty men were employed at the brewery, and seven teams of animals were used for beer delivery. In 1900, it had a capacity of 75,000 barrels annually.

Here is an interesting account by Frank Baldwin of Menominee, a stage driver who freighted supplies to Cedar River twenty-five miles north, midway between the latter community and Escanaba. He "hauled loads and loads of beer and whiskey to Cedar River." For $1.00, he brought a case of twelve quarts of unpasteurized beer, and they sold it at Cedar River for $1.25. They hardly made a trip without a load of beer. One Fourth of July, Baldwin

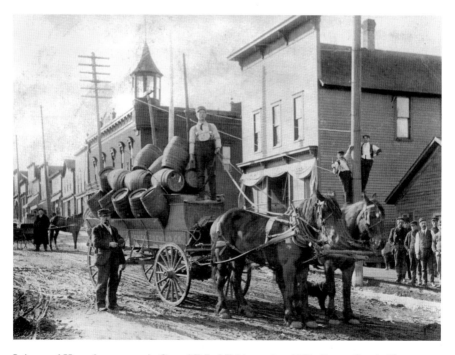

Leisen and Henes beer wagon in Crystal Falls, Michigan, circa 1905. *Courtesy Superior Views.*

hauled fifty-six cases of regular beer, ten cases of export beer and two dozen quarts of regular beer. This tale provides an idea of the popularity of beer in an offbeat location.

Jacob Leisen was born near Coblentz, Germany, on the Rhine River in 1828. He apprenticed as a cabinetmaker and then served in the Prussian Army (1849–52) as a sharpshooter. He immigrated to the United States in 1853 and settled in Wisconsin. He served in the Civil War and, in 1873, moved to Menominee, where he engaged in the brewing industry and played a major role in community affairs and local politics.

The secretary-treasurer of the Leisen and Henes Brewing Company was John Henes, who was born in Gammertingen, Germany, in 1852. He learned the brewer's trade in his hometown and came to the United States in 1871. He settled in Wisconsin and, for a number of years, was a brewer in Milwaukee, until 1874, when he moved to Menominee. At first, he was employed as a foreman in Adam Gauch's brewery. In 1876, he entered into partnership with his father-in-law, Jacob Leisen, and his name entered the company title. He was also actively engaged in community affairs and was the force behind the development of the Leisen and Henes business block.

Prior to 1900, Henes invented a bottle-filling machine that automatically transferred beer from barrel to bottles and prevented the escape of the carbolic acid gas. In 1903, the Henes-Keller bottling machine was put on the market and became an instant success as the leading bottling machine in the industry, with global sales. The machines were produced by the Henes & Keller Company in Milwaukee.

On the eve of prohibition, the officers of the company were: Louis J. Leisen, president; Joseph W. Leisen, vice-president; John Henes, secretary-treasurer and manager; Frank Schick, superintendent of bottling; and Wolfgang Binder, brewmaster. Seeing prohibition as reality, the officers of the Leisen and Henes Brewery consolidated with Menominee River Brewing Company and took the name United Beverage Company. The Menominee River complex was closed and sold. The United Beverage Company was located in the Leisen and Henes plant on Sheridan Road. They manufactured a non-alcoholic beverage called "Near-Beer" and later called "Silver Cream." Soft drinks were produced as well. In 1921, the company was overseen by the old rivals: Frank Erditz, president; Wolfgang Reindl, vice-president; John Henes, secretary; and Joseph W. Leisen, treasurer.

Members of the Leisen and Reindl families who were not involved with United Beverages moved into new businesses. The Leisen family was involved with the Menominee Stained Glass Works, which, by the late 1920s, was

producing automobile glass and metal products. They also owned the Leisen and Henes Block in downtown Menominee. Wolfgang Reindl was involved with Reindl & Sons, a farm equipment dealer.

Menominee-Marinette Brewing Company

With the end of Prohibition in 1933, the Menominee-Marinette Brewing Company was incorporated and, after a renovation of equipment, opened in the old Leisen and Henes plant. During its existence, it produced Old Craft Brew, which was promoted as a dark palatable beer and was its most popular beer. They also produced Menominee Select Beer (1933–50), Select Beer (1933–50), Menominee Bock (1933–54), Silver Cream Beer (1933–60), Brewers Best (1945–48), Big Mac Beer (1955–60), Menominee Champion Light Beer and, regularly during the holidays, Holiday Brew. Big Mac Beer came out in 1955 as the Mackinac Bridge connecting the two peninsulas of Michigan was under construction.

In August 1947, a unique Cold War ad appeared for their Silver Cream Beer, which was an interesting way to promote sales of their product. It read, "Good Beer too, is a great part of the American Way of Life…it's one of the simple pleasures of a Free People. Here Good Beer has come to mean extra pale Menominee Silver Cream."

The Menominee-Marinette Brewing Company kept the tradition of brewing in Menominee going until 1961, when an eighty-nine-year tradition came to an end when the plant closed. In 1966, one-third of the remaining plant was destroyed by fire, and in 1967, the entire complex was demolished.

IRON MOUNTAIN

The Menominee Iron Range, located in the vicinity of Iron Mountain, boomed with miners after 1870, and several population centers developed. In 1891, the Iron Mountain Brewing Company opened for an uncertain amount of time.

The Upper Michigan Brewing Company was in operation in 1890 and had opened with $75,000 in capital. Thomas N. Fordyce was president, and Lee Fordyce was secretary and general manger. Weekly, it produced 350 barrels of Upper Michigan Lager Beer. It was succeeded by the Henze-Tollen Brewing

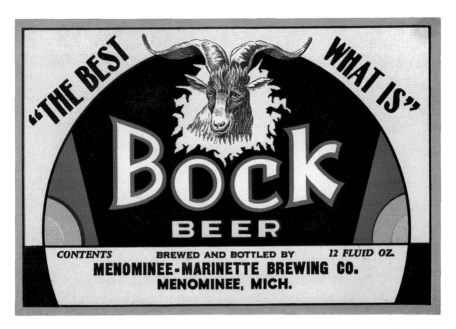

The slogan "The best what is" became popular with beer drinkers. *Courtesy of Brian Stechschulte.*

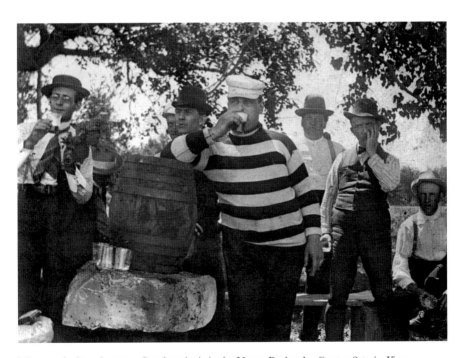

Miners enjoying a beer at a Sunday picnic in the Upper Peninsula. *Courtesy Superior Views.*

Company in 1899, which opened with $40,000 in capital. The owners were Louis A. Henze (1856–1914), a German immigrant, and Gustave Tollen (1851–1928), a Norwegian immigrant. The brewers were concerned with ensuring their product was "brewed out of choice materials" and it was "pure without drugs or poison." Two of their labels included Iron Mountain Beer and Bock Beer. After Louis died in 1914, his son Walter led the company as president, manager and superintendent, along with other members of the family. In 1918, the officers of the company were: Walter A. Henze, president and manager; Gustave Tollen, vice-president; A.R. Henze, secretary-treasurer; and M. Kriegl, manager of the bottle department and brewmaster. The brewery did well over the years but closed because of state prohibition.

By February 1920, the Henze-Tollen Brewing Company consolidated its interest with the Arbutus Beverage Company, and the new company actively promoted the sale of cereal beverages—Hope (light), Jinx (dark) and the Blue Bell brand of ginger ale, soda water, root beer, grape juice, imitation cider and other beverages. They had a plan to also go into ice cream and confectionery in an attempt to rebuild the business lost because of prohibition. The Arbutus Beverage Company remained in business until 1933. The Upper Michigan Brewing Company reopened, producing a bock beer, but the brewery lasted only five years.

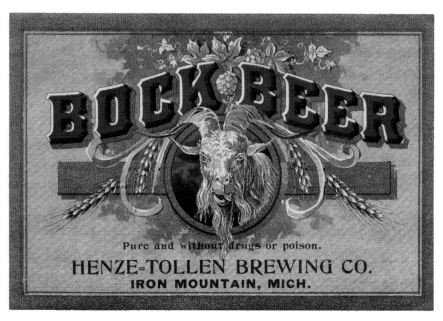

Bock Beer was usually sold in the early spring. *Courtesy of Brian Stechschulte.*

As traditions changed, women joined the men to have a brew during the warm summer months. *Courtesy Superior Views.*

WESTERN UPPER PENINSULA BREWERIES

In the western corner of the Upper Peninsula, the Gogebic Iron Range, the last of the iron ranges in the Upper Peninsula developed in the 1880s. The John Held Brewery opened in 1889 and continued producing beer until 1893. Five years later, the Becker and Knapstein Brewery opened for a two-year run, to be replaced by the Bessemer Brewing Company in 1900, which closed in 1918. Several miles to the west is the city of Ironwood, where business interests developed the Superior Brewery (1901–02), followed by the Ironwood Brewing Company, which lasted until 1918. In the end, the company officers were: Reiner Hoch, president; G.A. Curry, vice-president; Frank Dick, secretary-treasurer and manager; and Fritz Gretzinger, brewmaster.

Willebrand-Manistique Brewery

Following the usual settlement pattern, Manistique, which got its start in the 1880s, developed a strong industrial base with lumber mills leading the way. However, other industries developed: limestone quarrying and processing, a leather tannery, a charcoal iron foundry, a pulp and paper mill and numerous smaller enterprises that employed over one thousand workers. As a result, a good-sized immigrant population developed in Manistique and vicinity. It was also a major port on Lake Michigan, with Chicago to the south and train-ferry service from the Lower Peninsula.

The Willebrand family constructed a structure at Harrison, two miles north of Manistique, in 1898. In 1901, Theodore Willebrand opened the Willebrand-Manistique Brewery in the building. It was a plain, multi-storied structure located on Indian River near Brewery Dam. Three of Willebrand's sons and five other employees worked in the brewery where beer was brewed in eight vats between ten and twelve feet in height. They produced Golden Grain beer. Originally, beer was kept cold in the icehouse with ice cut from Indian Lake. Outside of the building, there was a tap and cup for thirsty passersby who might want a cup of refreshment before continuing on. A high fence surrounded the brewery to keep deer out because they would lap the beer from the drip trays and end up intoxicated.

In 1906, the Willebrands sold out to another party who renamed the operation the Manistique Brewery. In 1908, Anton Hiller was president and general manager, George W. Boucher was vice-president and N.A. Smith was secretary-treasurer. The brewery's Manistique Famous Beer became known throughout the area. For the next few months, the brewery prospered under the management of Tony Hiller and earned the reputation of making beer equal to any on the market, and the brewery became financially viable. However, for some unknown reason, in the early morning on September 3, 1909, John Brush and another arsonist cut a hole in the back wall, poured in kerosene and burned the structure to the ground. Approximately 350 bushels of malt, 4,000 pounds of fermenting yeast and 650 barrels of beer were destroyed. A few nearby buildings were saved, including the icehouse.

After the fire, some of the vats were used locally as snow rollers pulled by two teams of horses to flatten the snow. In an interesting development, in the spring of 1924, a kid digging through the old ruins found the only known bottle of Manistique beer, still filled, with a detached label, much to everyone's amazement. Because the brewery struggled to be profitable and the fact that the plant was only insured for $10,000, it was never rebuilt.

Soo Brewing Company

In the eastern Upper Peninsula, the city of Sault Ste. Marie was home to the famous St. Mary's River Canal and a growing number of industries—a leather tannery, a woolen mill, Union Carbide, etc.—which helped to create a base of thirsty workers. A series of breweries under the same owners developed beginning in 1882: Spitzig & Vogt (Voigt) Brewery (1882–88), Anton Vogt (Voigt) Brewery (1883–89) and finally A. Vogt (Voigt) & Company Brewery (1884–88). The city directories provide little detailed information about these breweries except that Anton Vogt was in the Soo at thirty-two years of age in 1882.

In 1894, John Navin & Company was a liquor merchant who was an agent for the Cheboygan Brewing and Malting Company. They operated out of Cheboygan but, for a while around 1909, had a bottling works in St. Ignace. Their celebrated Barligold beer was advertised as being "appreciated by consumers for its great purity and strength. Recommended by the most eminent medical authorities." In 1890, at St. Ignace, James F. Moloney was listed in the state directory as a "brewer and bottler of Lager, Birch Beer, Ginger Ale, etc" and as a liquor wholesaler and beer agent. If he was a "brewer," his operation must have been very small as we hear little of him in later directories.

The major brewery, the Arnold Brewing Company, was incorporated in July 1902 with $100,000 in capital. Edward Arnold from Escanaba was the president, Victor E. Metzger was the vice-president, and George Arnold, also from Escanaba, was the secretary-treasurer. A large-capacity, multi-storied brew house was constructed. The name lasted for five years, and in 1907, Charles F. Dunbar of Wausau, Wisconsin, and Richard R. Reinhart took over as president and secretary-treasurer, respectively. They changed the name to the Soo Brewing Company.

In 1908, John Leonhard Stroebel (1868–1945) arrived in Sault Ste. Marie and worked as a brewmaster for the Dunbar family, whom he had known in Wisconsin and now owned the brewery. Stroebel was born in Windelsbach, Germany, in 1867 and learned the art of cooperage and the handling of malt and the drying of hops. He came to the United States in 1888 and worked for breweries in New York; Three Rivers, Michigan; and Chicago before being offered the position at the Soo Brewery. He demanded the best equipment to produce the best beer and maintained high brewing standards. His brews were famous throughout the Great Lakes.

The massive brewery located on East Portage Avenue, which had been constructed in 1901, was Stroebel's domain and flourished under his

direction. Export was the most popular beer served on the diners of the Soo Line Railroad and on lake steamers. They also made Old Stock Porter, a medium beer; Rheinbrau; and a special Easter beer brewed in the spring. The beer was sold in bottles and kegs, and most of the production was for local consumption. At that time, there were hundreds of soldiers stationed at Fort Brady who enjoyed the local brew.

The company celebrated a decade of operation in 1917. At the time, the officers of the company were: L.S. Dunbar, president; Richard R. Reinhardt, secretary-treasurer and manager; and John Stroebel, brewmaster. These men had to close the doors of the brewing operation in early 1918. With a large investment in the building and equipment, the plant could not remain idle. In order to survive this reversal, Reinhart and his partners created the Soo Beverage Company, which produced non-alcoholic beverages and sodas. The near beer was never a success. At one point, the partners tried to induce Stroebel to make illegal beer, an idea he rejected. In 1922, Stroebel left the business and opened a successful food and general store.

With the end of Prohibition in 1933, the Soo Brewery eventually reopened, in 1937, and produced beer with the labels Su-Bru, Stroebel Soo Beer—"made on Lake Superior"—and Stroebel Old Stock Porter. Stroebel had a brief association with the company, and they produced the Stroebel label. When the quality of the beer deteriorated, Stroebel placed a small ad in the *Evening News* disclaiming his association with the brewery.

During these years, we have the memories of one of the company's last living employees, Ray Paquin. He first got a summer job at the brewery in 1942 when he was seventeen years old. He assisted the deliveryman hauling beer to the soldiers stationed at Camp Lucas and Fort Brady. During World War II, there were nearly ten thousand military personnel stationed at Sault Ste. Marie guarding the canal. As he recalled in an interview in 2011, "The soldiers drank at lot of beer." The market for Soo beer was limited to the city due to gasoline rationing and other wartime restrictions. The exiting of military personnel from Sault Ste. Marie, as the fear of a German attack on the canal ended, and the strong competition from the brewing powerhouses of Milwaukee and St. Louis that flooded the local market with Schlitz and Budweiser brought about the decline of the home-town brewery. As a result, the Soo Brewery closed in 1948.

As historian Jean Worth stated in 1968, "It is much easier today to make good beer than it is to sell it. The brewers said, 'Rubber tires killed the little breweries,' meaning that with the coming of truck transportation the local brewery was under new pressures of competition." There was a change in

drinking venues from the tavern to the home and thus from kegs to the six-pack in terms of beer buying habits. Then there was the problem with regional advertisement, which directly affected local breweries. For instance, the last of the local brewers, Bosch, sold throughout the Upper Peninsula and south to Alpena in Michigan and to Green Bay in Wisconsin and west to Duluth and Virginia, Minnesota. Sales could have been wider, but their advertisement budget would have been diluted in the process.

By 1914, the thirteen breweries in the Upper Peninsula employed nearly two hundred workers. Of this number, the majority were American-born, but immigrants, especially Germans, dominated the industry. In the spring of 1910, the federal census showed that the Copper Country, with its large number of breweries, and Menominee, with its concentration of eastern European immigrants, had the largest number of immigrants working in the breweries. There were thirty-nine immigrants working as owners, brewmasters, caretakers and cellar bosses, with Germans dominating the labor force. In the southern Upper Peninsula—at the city of Menominee, with its German, Austrian, Bohemian and Polish population—there were a variety of immigrant groups working in its two breweries.

The original breweries of the Upper Peninsula utilized the talents of the German immigrants and their strong brewing tradition. The breweries provided communities with new sources of revenue for the owners and the tax base. Besides, they brought to the public a new beer that was produced locally and thus much fresher than brews coming from St. Louis and Milwaukee, although the latter were popular and continue to be. A final benefit of the coming of the German brewers was that, throughout the Upper Peninsula, many of the brewers became involved with their communities. They participated in the life of the community, and many of them served on city boards and commissions. They were also involved in the development of banks, real estate and other industries and, thus, played a very positive role in their communities.

5

PROHIBITION

Since the mid-nineteenth century, Michigan had been struggling with the whole idea of controlling consumption and later the manufacture of alcoholic beverages. It is interesting to note that on July 1, 1850, the *Lake Superior Journal* reported that ten local males were installed as officers of the Algic Chippewa Division, No. 107 Sons of Temperance at Sault Ste. Marie. At the same time, the first German brewers in the Upper Peninsula were getting their start in the same community.

In 1853, a prohibition law was passed in Michigan, but it got bogged down in a statewide referendum debate, which concluded that the state legislature did not have the right to attach a law to a referendum. The law was declared invalid. Two years later, a prohibition law was passed, but it was full of loopholes and lack of enforcement measures. By 1857, Detroit had 420 saloons, 56 hotel and tavern bars, 23 breweries and 6 distilleries. Prohibition was on the statute books until 1875. In 1877, a new law required saloons to be closed on Election Day, prohibited the sale of alcohol to Native Americans and minors and allowed a county to prohibit the sale of liquor within its boundaries as a "local option."

Nearly forty years later, the temperance movement came to a popular vote on April 4, 1887, over a constitutional amendment. Would the people vote to make Michigan a dry state? At the end of the day, 178,470 voted for prohibition and 184,305 voted against it. This was a close result, with 5,805 votes, or 49.1 percent versus 50.8 percent, keeping Michigan wet. All of the Upper Peninsula counties, with the exception of Chippewa County, voted

against prohibition. This gave 6,409 (29.0 percent) votes for prohibition and 15,641 (71.0 percent) against prohibition, with the mining counties and their large immigrant population leading the way.

The Upper Peninsula continued to be home to a large number of saloons and resulting breweries, as we have seen. In 1909, there were some eighteen breweries or brewery branches, chiefly in the mining towns of the western Upper Peninsula. The saloons grew over the years as well. In 1891, there were 566 saloons, which rose to 684 in 1901, peaked with 920 eight years later and then went into a decline as eventual state prohibition approached. In 1917, there were only 421 saloons.

The Anti-Saloon League, which arose in Ohio in 1893, quickly became the major force in American politics to ban all alcohol manufacture and consumption. They did this through a strong lobby and printed word campaign to enforce existing prohibition laws and see that further anti-alcohol legislation was enacted. Their strong force of persuasion was extremely effective and hit the state of Michigan in 1916. In the election campaign, the battle was on. The Bosch Brewing Company took out an instructive ad in the *Houghton Daily Mining Gazette*, which shows how beer was viewed by a strong promoter of the wets.

> *The popularity of beer is not confined to any particular class or classes of society. Beer is the great liquid food just as bread is the great solid food. Both may be found in the humblest cottage or the grandest mansion.*
>
> *Beer appeals to the workingman because it is a mild and in-expensive beverage which promotes not only sociability but furnishes relaxation after the hours of toil. Further, the American mechanic has learned that beer means sobriety, steady nerves and healthy body.*
>
> *With the wealthier classes, beer is the favorite beverage, not because of its low cost but because if it's scientifically proven food value. The sentiment against intemperance is steadily leading the rich as well as the poor toward pure beer, the great temperance drink.*

The advertisement, titled "Prohibition vs. Temperance," ended with: "All classes of men of all the great civilized nations agree in their endorsement of beer." Being the largest brewer in the Copper Country, the Bosch Brewing Company advertised on the eve of the election against prohibition, invoking health authorities: "The London Hospital says that 'Beer is par excellence the nutritive alcoholic beverage—when a man drinks Beer, he drinks and eats at the same time, just as when he eats a bowl of soup.'" Another advertisement

noted that prohibition would confiscate and close every brewery in Michigan; would stop the making of malt, brewed or fermented cider beverages in Michigan; and would close a market for barley, hops, grapes and apples grown on Michigan farms. In a forecast for future developments, the writer added that prohibition could not regulate the bootlegger, but extra taxes and salaries would be needed for extra police to trap bootleggers, and finally, strong drink could and would be shipped into Michigan in trainloads. At the same time, the Congregational Church Sunday School placed a political advertisement: "25,000 Young Men a Year is the toll of the licensed saloon each year in Michigan. One out of every 5 young men acquires the drink habit. Have You a Boy to Contribute? If not Vote for Prohibition."

During the weeks prior to the November election, there was a barrage of ads and articles for and against prohibition in the *Evening News*. On November 6, 1916, the paper reported that eight "leading" physicians of Sault Ste. Marie adopted a resolution stating that, according to "painstaking experiments of European and American scientists that alcohol is a definite poison" and "that the general use of alcohol as a beverage is the direct or indirect cause of a very large percentage of our crime, insanity, epilepsy, feeble-mindedness, disease, divorce, child misery and pauperism." They condemned the use of all alcoholic beverages, including wine and beer. At the same time, they noted a modern concern for pregnant mothers drinking alcoholic beverages and its negative effects on the unborn child.

A month later, the paper carried a large anti-prohibition ad, which was prophetic in its view: "Prohibition means hypocrisy, blind tigers, law-breakers and crime. Prohibition, the kind proposed for Michigan would mean: train loads of intoxicants coming into Michigan from Ohio, Illinois, Wisconsin and New York States...Michigan would obtain intoxicants—Michigan would pay for them, blind tigers would sell them, bootleggers would handle intoxicants illegally, and millions of dollars would be spent outside the confines of the state." The ad continued, "The Dry Amendment viciously provides for the Confiscation of property valued at $30,000,000 and the throwing of 50,000 jobless men into the labor market." Much of the property and jobs lost were related to the brewing industry in the state.

Despite ads such as these, paid for by the brewers promoting beer as a healthy and sociable drink, on November 7, 1916, the Michigan voters passed the constitutional amendment—353,378 for and 284,754 against—outlawing the manufacture, sale and transport of alcoholic beverages. In the Upper Peninsula, the Dries carried eleven of the fifteen counties, winning over 60 percent of the vote in six of the counties

inhabited predominantly by first- and second-generation immigrants. The constitutional amendment went into effect on May 1, 1918. Several weeks prior to this date, brewers throughout the state ceased operation and sold their remaining stock.

On May 3, the Richter Beverage Company in Escanaba was promoting its new beverage, Ricto, a few days after prohibition went into effect. By the Christmas season of 1919, the company advertised, "Let us furnish the beverages for your Christmas observance." Still promoting its fine product in full and half pints, the ad continued, "Because our cereal beverages are all made of No. 1 brewer's malt, with pure high grade corn, cerealline, and choice Oregon hops. No dope about that." It also made soda and near beer with pure artesian water.

At the onset of state prohibition, the police were on a mission to seize beer and spirits in the opening weeks of May 1918. More than one thousand bottles of beer and many gallons of whiskey were seized by the Escanaba police in twenty-four locations. In their biggest haul, the police raided an Austrian boardinghouse at the lumber mill town of Wells and seized eighty-three cases of beer and ten and a half gallons of whiskey. At another boardinghouse, the owner, Frank Pacquin, was found with ten cases of Richter beer and a double case of Pabst Blue Ribbon beer. He said that it was for his private use, but the police said that by having it in a boardinghouse, possessing it was illegal. They seized it, along with other illegal beverages.

Violating the constitutional amendment and the law of the land would become part of American life. It was said that if you could not get a drink within minutes of arriving in a town, you were obviously a prohibitionist and did not need a drink.

Nationally, Prohibition came about with the passage of the Eighteenth Amendment and went into operation on January 17, 1920 and was enforced by the Volstead Act. By the time of national Prohibition, the word was out that if you wanted to know how to brew or obtain liquor in any quantity, just check with Michiganders, who had two years of experience.

In 1918, at the onset of state prohibition, the following breweries were in operation: Calumet Brewing Company, Calumet; beer agencies of Pabst, Scheuermann, and Joseph Schlitz; A. Haas Brewing Company, Houghton; Henze-Tollen Brewing Company, Iron Mountain; Bosch Brewing Company, Lake Linden; Upper Peninsula Brewing Company, Marquette; Leisen and Henes Brewing Company, Menominee; Menominee River Brewing Company, Menominee; Richter and Escanaba Brewing Companies, Escanaba; Soo Brewing Company, Sault Ste. Marie; and the beer agencies Gettleman Brewing Company and Minneapolis Brewing Company.

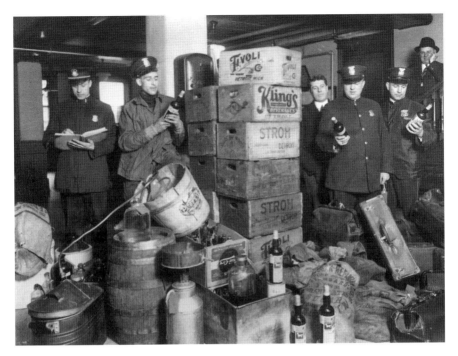

Typical police raid confiscating and destroying hard spirits and beer during Prohibition. Despite these futile efforts, by 1929, beer production rivaled 1919 production. *Courtesy Superior Views.*

During these years, most Upper Peninsula breweries closed. Some took different routes to maintain some type of profit. In the country, some produced canned hopped malt syrup, which could be legally made and sold but was illegally used in homebrewing. Some of the breweries, such as Richter in Escanaba, reemerged as beverage companies. Richter became Richter Beverage Company and Leisen-Henes in Menominee became United Beverage Company, producing malt tonic, soft drinks and ice cream. But even the transition to soft drinks and ice cream had its problems.

Since World War I was in full swing, sugar was rationed, and thus, soft drinks could not immediately fill the void of the loss of beer. At the same time, city commissions created special licenses for "refreshment saloons," which sold soft drinks and were patrolled by the police. In the early 1920s, one Prohibitionist newspaper, the *Escanaba Daily Mirror*, unrealistically reported that the 3,285 saloons in Michigan had reopened, serving lunches and dispensing what was advertised as "temperance beer." The following runs contradictory to the hopes of prohibitionists. In March 1921, federal agents raided ten soft drink parlors in Gladstone. Of this

number, five were selling beer, the rest were selling hard liquor and one allowed gambling.

The Upper Peninsula Brewing Company sustained one of the heaviest losses as a result of the passage of the amendment of any of the breweries in the Upper Peninsula. Charles Meeske had made heavy investments in the plant from year to year. He had spent money developing the architecture of the brewery to look like a Rhine castle, as he had taken great pride in the building's attractive appearance. Once Prohibition came, the building stood silent and forlorn, and Meeske's business had ended.

Within days of the arrival of state prohibition, the distillation of hard liquor or moonshine was underway throughout the Upper Peninsula and sold locally or as far as Chicago. This story is well told. However, the story of homebrewing, or *heimgemacht*, as it was called by the German immigrants, was seen as too common and, thus, is infrequently told as part of violating prohibition. Despite the lack of local information, we can look at the national scene. Homebrewing became immediately popular and malt and hops stores popped up across the nation. Former breweries sold malt extract syrup, which buyers said was to be used for baking and making near beer and non-alcoholic beverages.

Making homebrew was so common that in June 1919, just a year after state prohibition started, Detroit judge Christopher E. Stein said in front of a fellow to be arraigned for making homebrew, "If arrests are to be made for brewing beer 'at home,' we might as well get ready to handle about 50,000 such cases." The Prohibition Bureau, in 1929, estimated that 22 million barrels (thirty-one gallons per barrel) of homebrew were made annually. This was almost the same amount of legal beer sold in 1919.

In the UP community of Daggett, home to a substantial German immigrant population, homebrewing was common. The Michigan State Police stopped a local resident, Gus Pluchak, on July 3, 1926, to have his brakes checked. In the process, they found that he was transporting homebrew with a "kick." He reported to the police that it never entered his mind that he was violating the law for making and running beer. He summed it up, "All my neighbors make their own beer and nobody thinks anything of it." He lost the beer, and his friend in Menominee had a dry Fourth of July.

Talk to old-timers like Joe Meni of Gwinn, and they will tell you that most Upper Peninsula households were following the national trend and making homebrew. In 1932, when Nunzio Gianunzio was elected mine inspector of Dickinson County, his family brought out twenty cases of homemade beer for the celebration. Michigan beer drinkers reported on homebrew: "It's great; better than the real stuff," "It has the kick," "It brings back the 'good old days.'"

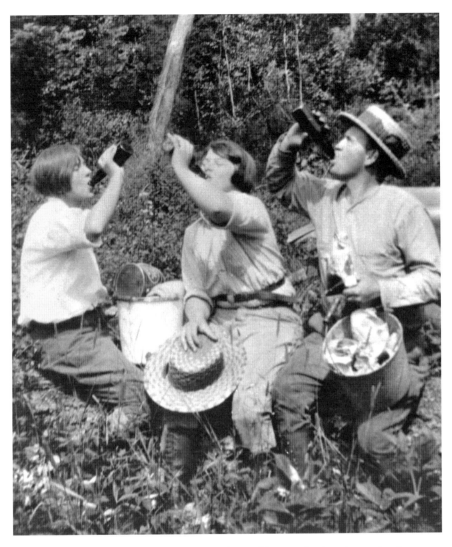

Prohibition dropped restrictions on women, who could now enjoy beer in speakeasies or on a picnic. *Courtesy Superior Views.*

The popularity of homebrewing can be seen in the following colorful poem, which was the national rage for a while:

> Mother's in the kitchen, washing out the jugs;
> Sister's in the pantry, bottling the suds;
> Father's in the cellar, mixing up the hops;
> Johnny's on the porch, watching for the cops.

Throughout the nation, many breweries were licensed to make near beer by first making regular beer and then boiling off the alcohol so that the finished product was one-half of 1 percent alcohol and thus "legal." In reality, many gallons of near beer never went through the de-alcoholizer, either by the brewer's clever deceit or the greed of the crooked Prohibition agent. Then, if necessary, there was "needle beer," which was near beer that came with a package containing a portion of the alcohol boiled off and syringe to squirt the alcohol back into the beer.

Because hard liquor and beer were illegal, all of the 426 saloons in operation throughout the Upper Peninsula in 1917 closed their doors. The 12 soft drink shops quickly expanded to 232 soft drink establishments four years later and replaced all of the saloons. In Calumet, which had 47 saloons in 1917, there were 24 soft drink shops in 1921. Of that number, 8 were operated by former saloonkeepers. In the central Upper Peninsula, Ishpeming, which had 29 saloons, saw them replaced with 13 soft drink parlors, but only 7 former saloonkeepers got involved. Some of the saloonkeepers opened billiard parlors to keep the revenue coming in. In 1917, there were 64 billiard parlors operating in the Upper Peninsula, and four years later, the number increased 64 percent to 115 parlors. Although not available on statistical charts, the soft drink shops and billiard parlors did a brisk business selling illegal alcohol.

The *Calumet News* provides us with some insights on what saloonkeepers planned to do to be economically viable. A. Turcotte, who had been in business in Houghton for twenty-six years—along with John M. Foley, Charles McGann, Antonio Giuglio and A. Croze—remained in business conducting lunch rooms, refreshment shops or pool and billiard parlors. William and Martin Yauch Jr. retained the saloon room in the Haas Brewing Company's building and turned it into a billiard hall. Martin Yauch Sr., after operating saloons for over forty years in Houghton County, planned to retire. However, he opened a billiard hall in Houghton. The Douglass House, the finest hotel in Houghton, kept its bar open as a lounging room for the sale of refreshments. It does not take much imagination to see how these refreshment locations would quickly turn to selling illegal beer and spirits. The folks at Leisen and Henes in Menominee went the traditional route of making soft drinks, but other members of the family and brewery got into stained-glass making, building construction, rental properties and the sale of farm equipment in order to cut their losses. The Hoyler family in Escanaba had been brewers. Richard retired and his son Fred got into the bakery business, still working with grain but in a different form.

Prohibition

During the years of Prohibition, there were a number of attempts to bring about change or modification of the law. There was talk of declaring beer a "necessary medicine" to be available with the doctor's prescription. As the years dragged on, the law was violated more often. As crime and violence rates rose and tax revenue was lost, people slowly began to take a new look at the amendment. In July 1923, Michigan senator James Couzens presented his ideas at a meeting of Bay City businessmen. He was for the Eighteenth Amendment but with modifications, since he found Michiganders were dissatisfied with conditions and the fact that there were too many laws regulating individuals. He continued:

> *Now, I think it is for the good of the country that the Volstead Act, the law that fixes the alcohol content of beer, should be modified to permit the manufacture of 5 percent beer, or from 2½ to 3¼ proof depending on your scale of measurement. It would do much to restore contentment and peace to this country.*

He pointed out that the Anti-Saloon League had promoted the fact that 90 percent of people drank beer and most did not want hard liquor. Couzens took this unpopular position because he was concerned about the American public. This position did not affect his election to the United States Senate in 1924. It would be another decade before the law was changed.

The other development that came during the years of Prohibition was that people became used to lighter versions of lager, which were more available during the Prohibition years. When breweries resumed operations, they generally followed the trend.

When Prohibition ended, relatively few pre-Prohibition breweries reopened in the Upper Peninsula. Richter Brewing became Delta Brewing, Haas and Bosch came back in the Copper Country, as did Soo Brewing in Sault Ste. Marie. Some of the smaller breweries that reopened stayed in business for a relatively short time. Eventually, larger national breweries would come to dominate the market. This was true after World War II, when television enabled breweries to advertise their product nationally. The post-Prohibition revived breweries—Haas and Bosch—survived into the 1950s and 1970s, respectively. Thus. one major phase of beer making, which existed for nearly three hundred years, came to an end.

6

CRAFT BREWERIES IN THE UPPER PENINSULA

The history of craft brewing in Michigan goes back to 1985, when Larry Bell of Kalamazoo started small and opened a brewery. It was a new phenomenon, and at the time, everyone in southern Michigan talked about Bell's beer. By 1989, Bell employed nine people. That number has since grown to over two hundred employees. Many saw the popularity of his King Oberon and other beers as a reason for getting into microbrewing themselves. A new industry was born and quickly spread throughout Michigan.

Since the early 1990s, craft brewing has become an important industry throughout the Upper Peninsula. The breweries are varied, depending on the direction taken by the proprietors. No one brewery is similar to the others except for the fact that every brewer enjoys his/her work, making new types and flavors of beer, presenting their handicraft to the public and learning what the customers appreciate about beer. As a result of their love of beer making, it has been a delightful pleasure for me to undertake interviews with these beer-making pioneers.

All of the breweries in the Upper Peninsula also operate brewpubs. They fall into a number of specific classifications. One category is made of the breweries that can, or bottle, and sell their product outside of the Upper Peninsula. These breweries include Keweenaw Brewing Company and Blackrocks Brewery in Marquette and Upper Hand Brewing Company in Escanaba. Then there are breweries that bottle their product—like Ore Dock Brewing Company in Marquette and Brickside Brewing Company in Copper Harbor—and sell it

within the Upper Peninsula. Three breweries that first developed as restaurants and then added brewing include Jasper Ridge Brewing Company, Ishpeming; Vierling Restaurant, Marquette; Red Jacket Brewing Company in the Michigan House, Calumet; Hereford and Hops, Escanaba; Tahquamenon Falls Brewing Company; Library Restaurant, Houghton; Chocolay Brewing Company and Bayou Restaurant, Marquette; Shooters Firehouse, Munising; and the Dunes Saloon and Lake Superior Brewing Company, Grand Marais.

CALUMET

Red Jacket Brewing Company

The Red Jacket Brewing Company takes its name from the early name of the village of Calumet. The owners are Sue and Tim Bies, who are originally from Alpena in the Lower Peninsula and came north when their son attended Michigan Technological University. The couple purchased the Michigan House in 2001, which had been built in the early twentieth century by the Bosch Brewing Company. It was a perfect location to open their restaurant, the Michigan House Café. They had been homebrewers and decided that adding a brewery to their restaurant would be a perfect fit.

The Bieses like experimental brewing, brewing in small batches and maintaining the purity of the brewing process. In the past, they have experimented with spruce beer, using spruce tips gathered in the spring; created a Cherry-Ancho Stout, using cherries from their tree and included the pits, which provided the beer with an almond-flavor; and experimented with an Apple Juniper beer. They try to use local ingredients when possible, as with the cherries and apples, but found that buying large quantities of fruit would be unprofitable. As part of their environmental concerns, they avoid using harsh chemicals to wash their equipment and see that spent grain goes to making bird feeders or to farmers to feed their livestock.

The Bieses started small, with a half-barrel system, which they quickly outgrew. They now have a nine-barrel system and produce one hundred barrels annually. They make four to five beers all the time, and they produce, "just a good, clean beer." In place of fermenters, they use milk chillers that they get from the local dairy and work great for them. Although Tim continues to do some brewing, they have hired Brian Hess, who started as a homebrewer and is now a chemical engineer for Calumet Electronics. Hess

finds time to go to the brewery where the Bieses set up the ingredients, and he brews uninterrupted.

Their first and flagship beer was the Coffee Oatmeal Stout, and it remains the favorite of customers. The other staple beers are Downtown Brown, Taxi Pete Wheat, Keweenaw Cowboy IPA and Cold Hearted, an American pale ale. The Bieses avoid fruit beers but have experimented with honey beers. One of the more special but limited beers they produced was Shot Rock Wee Heavy Scottish Ale, which they presented at the curling tournament held in Calumet. One year, for Presidents' Day, they revived one of George Washington's original recipes. It was heavy on bran and molasses. Although it was fun to experiment, they said the beer was "not very good," although customers tried a pint for the celebration.

The craft beer complements the fresh food the restaurant presents. The combination works well for their customers, as does the location in the historic Michigan House with its many artifacts and photographs.

COPPER HARBOR

Brickside Brewery

The Brickside Brewery has the distinction of being the most northerly brewery in the state of Michigan. It is a nanobrewery, the size of which matches the small population of the community, which is a surprise to visitors who cannot believe that Copper Harbor can support a brewery. Beer is hand-bottled so that it can be sold to aficionados from Calumet and elsewhere who enjoy the beer but not necessarily the drive north. Those who venture to the end of US-41, after stopping at one of the restaurants to enjoy a Cornish pasty and then a beer at Brickside, will move on to the boat ride across Lake Superior to Isle Royale National Park or return home.

The Brickside Brewery was the idea of owner and brewer Jason Robinson. He started with a homebrew kit as a gift from his sister, and he brewed for seven years. Later, he went through the American Homebrewers Association distance-learning course and then interned at Jolly Pumpkin Brewery. Everyone who donates five dollars or more gets their name on a brick on the brewery wall; others get their names on equipment. This practice led to the name of the brewery. When asked what he loved about making beer, Jason said, "The process itself, the smell of warm mash, the bitter scent of

hops. That first taste of a new batch coming out the way I wanted. And yes it sounds cheesy, but when people say its tastes great I'm amazed."

His idea to open a brewery developed in the summer of 2011. The brewpub opened on June 9, 2012. Beers available at Brickside include Park Bench Porter, Stone Ship Stout, Mosquito Lake Pale Ale and his most popular beer, UP IPA. Robinson brews a large variety of seasonal beers, and his brewpub remains open throughout the year.

ESCANABA

Hereford and Hops Brewpub

The Upper Peninsula saw its last brewery—Bosch Brewery in Houghton—close in 1973 after a struggle to remain open despite overwhelming competition from the national beer giants like Anheuser-Busch. Twenty-one years later, the first craft brewery, Hereford and Hops, appeared on the scene in Escanaba on December 7, 1994. The brewery was the idea of retirees Don Moody and Jack Bellinger, neighboring farmers in Rock, Michigan. Don raised Hereford cattle and planned to use them at his self-grill restaurant in Escanaba, thus, the name of the restaurant. At the time, self-grill restaurants were popular throughout the Midwest. They purchased the old Delta Hotel, which had been constructed in 1914; in more recent years it had become the Bishop Noa Retirement Home. They reportedly purchased the structure for a song and got to work developing the restaurant. The restaurant was popular, and it prepared one thousand steaks per weekend.

The original brewery started with four small fermenters, but sales took off, and it was soon installing a double fermenter. Today, the brewery operates a seven-barrels system. The first seven-barrel of Whitetail beer was sold out in a day and a half. At first, there was a concern that the local beer drinkers would rather drink the nationally advertised Stroh's or Miller Light, but that soon changed. Being the only microbrewery in the Upper Peninsula attracted out-of-towners who came from Manistique, Iron Mountain and even Marquette. This was a new taste experience for beer lovers. As more breweries developed in their hometowns, fewer people traveled the sixty to eighty miles for a craft brew, but business has continued to be steady for Hereford and Hops. Today, the brewery attracts a younger beer drinker.

The staple beers of Hereford and Hops are Cleary Red, Whitetail Ale and Redemption IPA, which is their most popular beer. The company has eight to ten varieties on tap at a time and produces over forty styles during the year. Beer is also available in growlers for offsite consumption.

A number of the brewery's beers have won awards. At the Great American Beer Festival, its Cleary Red and Schwarzbier won bronze medals. The World Beer Championship was a bit of a bonanza for brewer Mike. His Whitetail and Schwarzbier took gold and his Oatmeal Stout came away with the bronze.

A mug club was started at Hereford and Hops in 2004 with 60 members. Soon 88 members had purchased handmade ceramic mugs. Each year, they are presented new mugs with the year's date on the side. The muggers receive twenty to twenty-two ounces of beer for the regular price and are given gift certificates for additional beer so the brewpub is not violating state law by dispensing free glasses of beer. Members of the mug club now number 239.

The brewery plays an important role in the local economy. Don Moody worked closely with state senator Tom Casperson and state representative Ed McBroom to promote equitable beer laws, allowing big breweries and smaller operations to share shelf space. Hereford and Hops is a member of the Michigan Brewers Guild, which promotes favorable beer laws in the state legislature. Each year, the brewery hosts a beer festival, which includes beer, wine and a pig roast and raises money for United Way. In 2013, some six hundred people attended the festival, and they raised $5,000.

Since its opening, Hereford and Hops has been doing well, although as more breweries have opened, the long-distance clientele has declined. They have gone from 540 barrels in 2004 down to 500 in 2014. The two grills have been replaced by one, along with a Mongolian grill, the only one in the Upper Peninsula. As Escanaba is a meat-and-potatoes town, these grills work well. Reservations are necessary for the restaurant but never for the tavern-brewpub. Hereford and Hops is located to the south of the main "beer route" along Lake Superior, and it feels the effects at times. The restaurant does little formal advertising but has discovered that customers find them through their phone apps and beer guides. In recent years, people are going on brewery vacations, spending a week in the Upper Peninsula visiting all of the breweries. Brew tourists arriving from Chicago, Milwaukee and Green Bay find their first brewery in the UP in Escanaba where they begin their UP brewery tour. In an interesting development, the planned Upper Hand Brewery (Bell's), which was under construction in 2013–14, attracted people who thought it was opened but went to Hereford and Hops for a beer when they found it under construction. The brutal winter of 2013–14 also drove

many people indoors, where they enjoyed a craft-brewed beer.

Upper Hand Brewery

The Upper Hand Brewery in Escanaba is the idea of Larry Bell, president and founder of Bell's Brewery, Incorporated. As mentioned, Bell was the first craft brewer to get started in Michigan. Today, the successful company sells its products in twenty states, Puerto Rico and Washington, D.C.

Bell's Brewery headquarters is located in Comstock with its original brewery and brewpub in Kalamazoo, both in the Lower Peninsula. Bell's new brewery in the Upper Peninsula is a $2.5 million venture. As Larry Bell explained, "The name for the local business, the Upper Hand Brewery, relates to how people show where the UP is with one hand and refer to Lower Michigan with the other hand."

Bell has had long family ties to the Upper Peninsula. Around 1911, his Danish ancestors immigrated to the Upper Peninsula. He has maintained ties to the region through visits and property ownership.

Construction began in November 2013 on the 11,550-square-foot brewing and bottling facility, with a 20-barrel system capable of producing more than 6,400 barrels annually. In the fall of 2014, the facility began producing draft beer for kegs and bottled beer in December, with the tasting room opening two months later. Upper Hand's initial beers were: Upper Hand Logger, Escanaba Black Beer and UPA, which stands for "UP Ale."

Tastings and tours are planned. Although Bell's brand has been sold in the UP for some time, he has now realized his dream of selling his beer in the UP, produced at his Upper Hand Brewery centrally located in Escanaba.

GRAND MARAIS

Lake Superior Brewing Company

The Lake Superior Brewing Company at the Dunes Saloon is the social center of tiny Grand Marais on the shore of magnificent Lake Superior. It is a brewery, eatery and store. As its apropos slogan says, "We're a little hard to find, but harder to forget."

Chris Sarver opened the brewery in the mid-1990s when brewing got its start in the state. Chris was from the Brighton area of lower Michigan, was laid-off by an auto company and sought relief in brewing. Today, he operates a winery in Oregon but continues as the proprietor of Lake Superior Brewing Company. The brewpub opened in late 1995, making it the second microbrewery to open in the Upper Peninsula.

Chris started brewing and then hired Dave Beckwith as brewer. Dave learned the restaurant and saloon trade from his family's business in Grand Marais and was hired to operate the kitchen. He asked to be taught brewing as well. He was brewer from 1995 until 2009 and is presently general manager.

The brewery produces Belgian Gold (Belgian pale ale), Blueberry Wheat (fruit/vegetable beer), Cabin Fever ESB (Extra Special/Strong Beer ESB), Hematite Stout (American stout) and Oktoberfest (Märzen/Oktoberfest). Their complete list of beers runs to over a dozen.

As one visitor wrote, "Grand Marais is the type of laid-back harbor town that embodies the word 'vacation.' With its amazing beach and harbor, lakeside living vibe and cool local businesses, it's definitely the sort of place you could go to de-stress for a while (and maybe never come back)."

Being the only tavern in town, locals, tourists and staff mix together as if they have known each other for years. The décor channels a 1970s vibe, with wood tiled ceilings and a few stained-glass lamps on the wall. They serve brew food.

Houghton

Keweenaw Brewing Company

The Keweenaw Brewing Company, named after the peninsula it sits on, is the largest brewer in the Upper Peninsula. It was established by Paul Boissevain and Richard Grey and opened its doors in 2004. Paul is an avid beer drinker and had experimented with homebrewing. The two of them worked together at an oil company in Colorado and would have a few beers after work at the Wynkoop Brewpub in Denver. After changes came to the company and they lost their jobs, the questions of what was next came up. Richard had gone to Michigan Tech, and he and his wife, Stacia, wanted to retire in the Copper Country. The Boissevains visited the area and felt that

Widow Maker Black Ale, refers to the one-man mining drill or "widow maker," so feared by copper miners. Keweenaw Brewing Company, Houghton, Michigan. *Courtesy R.M. Magnaghi.*

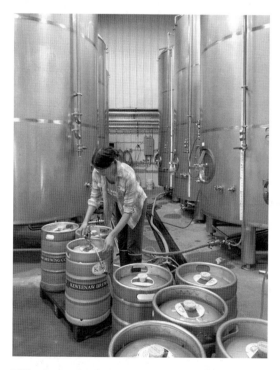

Filling kegs at Keweenaw Brewing Company, Houghton, Michigan. *Courtesy R.M. Magnaghi.*

it was the place to move. "It was like Boulder, Colorado, without the people," observed Paul.

Paul and Richard decided to open their small brewery in a storefront on Shelden Street at the west end of downtown. They stressed to the business community that they were opening a brewpub and would not serve food. Within a year, they had to expand to the space next door, and in 2007, they opened the deck with adjacent parking. Their brewpub has a pleasant ambience and attracts a cross-section of the community. Paul noted that when Michigan Tech is hiring new personnel, they point out the social benefits of having a brewpub in town.

As the brewpub owners looked around, they saw that there was no one in the Upper Peninsula canning beer. Plans were made to go into this new field. They found an empty warehouse in South Range, a few miles south of Houghton, and developed a now flourishing brewery with plenty of space—twelve thousand square feet—and all of the

Canning at Keweenaw Brewing Company, Houghton, Michigan. *Courtesy R.M. Magnaghi.*

Keweenaw beer ready for shipment. *Courtesy R.M. Magnaghi.*

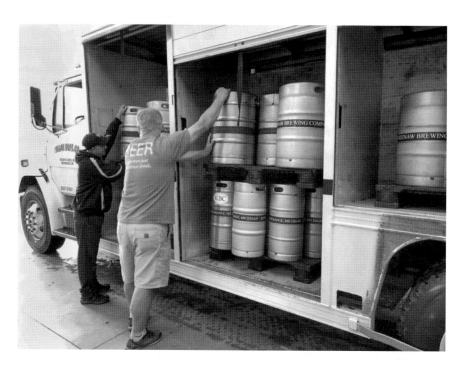

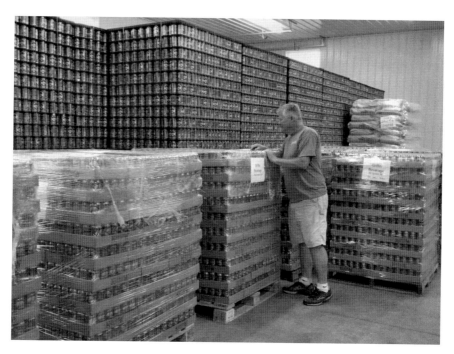

Above: Breweries maintain over 250,000 cans for efficient processing. *Courtesy R.M. Magnaghi.*

Opposite, top: With Richard Grey, Paul Boissevain opened the Keweenaw Brewing Company in 2004. *Courtesy R.M. Magnaghi.*

Opposite, bottom: Driver and Paul Boissevain loading beer to be sold throughout Michigan. *Courtesy R.M. Magnaghi.*

latest equipment for brewing and canning. Their beer is now represented by a number of distributors throughout the Upper Peninsula and into the Lower Peninsula of Michigan, Wisconsin, eastern Minnesota and as far as the Cleveland, Ohio area. Their success has been phenomenal. Their brewery operation has stimulated the local economy with jobs, tax revenue and a pleasant and convivial setting where people can stop and enjoy a beer with friends.

Library Restaurant and Brewpub

Situated in the heart of downtown Houghton, the Library Restaurant was renamed from Board Trade Café to reflect the books on shelves surrounding its diners. In 1967, John Davis opened the Library. It served beer and

peanuts and gradually developed into a restaurant. In 1985, Joe Cortwright and partners bought it from Davis, and it became one of the best restaurants in Houghton. After a fire in 1995, the structure was rebuilt, and two years later, the brewery was added.

The brewer, Bob Jackson, is from Duluth and got started homebrewing in 1985. Before Jackson arrived, the owners and kitchen help brewed beer without experience and created a clean but bland brew, so Jackson is considered the first brewer who created good and noticeable beers. He introduced new beers and improved the quality of the original beers. There are seven staple beers—Hefeweisen, Keweenaw Golden Ale, Rabbit Bay Brown Ale, Coppertown Pale Ale, India IPA, Redbrick Rye and Shafthouse Dry Stout—and a wide variety of light beers, hoppy beers and dark beers. The customers especially enjoy the IPA, which is one of their standards, and they grouse when it is not available. They find the Coppertown Ale gets them through until a new barrel is brewed. Jackson also brews seasonal beers: Oktoberfest in autumn, Boch in spring, Maiboch in May (a summer lager) and a Belgian-style Tripel. He also produces some special malty beers that he developed when there was a shortage of hops.

Presently, demand exceeds capacity during the busy summer and winter months. The brewpub has a five-barrel system with a capacity of between 240 and 250 barrels per year. There are plans to expand, which will allow Jackson to do more experimenting and develop new recipes.

The restaurant and brewpub attract a varied clientele of students—seniors and graduate—professional people, college professors, workers and anyone who enjoys fine beer.

ISHPEMING

Cognition Brewing Company

The Mather Inn was opened in 1932 as a hotel for Cleveland Cliffs Iron Company guests. When it first opened during Prohibition, it did not contain a tavern or taproom. During its heyday, however, it was the place to be and was the temporary home to celebrities such as director Otto Preminger, composer Duke Ellington and stars James Stewart, Lee Remick, Ben Gazara and Eve Arden, to name a few, for the shooting of *Anatomy of a Murder* in 1959. The inn's bar and restaurant closed in the 1980s and remained vacant until

it was turned into apartments, which opened in 2014. It is into this historic setting that Cognition established itself. The origin of the name, reports brewer Brian Richards, goes back ten years when he planned a brewery and came up with the name, referring to customers who when drinking the brew would be cognizant of the flavor and texture of the beer in the process of enjoying it.

Jay Clancey, who considers himself an "active amateur beer aficionado," was thinking of developing a brewery in Ishpeming and saw the value of moving his planned operation into the closed taproom of the hotel. Working with Richards, they developed the Cognition Brewing Company. Richards had brewed for thirteen years and recently brewed for Blackrocks Brewing Company. Richards and Clancey worked diligently to create a seven-barrel state-of-the-art operation. When in full operation in 2015, it produces four hundred to five hundred barrels of beer annually. It is Richards's goal to develop bold and unique beers that inspire conversation in a nostalgic, dark-wood bar.

Jasper Ridge Brewery

As the city of Ishpeming's business district moved to the side of US-41, Paul Argall developed the Country Village complex of shops, motels and convention center. In the fall of 1996, BCBM Management of Ishpeming opened the Jasper Ridge Brewery and Restaurant as a major part of the center. The name of the brewery comes from Jasper Knob, a high bare-topped hill, in the center of Ishpeming composed entirely of jasperlite. Sometimes it is referred to as the largest standing semiprecious stone in the world. The brewery is affectionately referred to locally as the Ridge.

Pat Meyer is the general manager. Karl Lehmann was the first brewer and was followed by Grant Lyke, who started as assistant brewer and became head brewer in 2012. Since September 2014, Travis Charboneau has been brew master at Jasper. A Gaylord native, he brewed for four years at Big Bucks Brewery and is known as a master brewer in Michigan. Jasper Ridge began developing a variety of beers, starting with a wheat beer and evolving its varieties to suit local tastes. Its four staple beers include Pale 41, Ropes Golden Wheat, an unnamed brown ale and an amber ale with a lower alcohol content. It also brews a German kölsch. The Ropes Golden Wheat, which was the brewery's first beer, has remained the perennial favorite with customers. They have eight beers on tap and have some twenty varieties that can be brewed. The brewery has an annual production of 320 barrels.

Jasper Ridge Brewery is a full service bar and restaurant. Beer is available

on tap and in growlers for offsite consumption. Being located next to US-41, it is a favorite of tourists to the area.

MARQUETTE

Blackrocks Brewing Company

The story of Blackrocks Brewing Company and its founders David Manson and Andy Langlois is a leap into the unknown, much like its namesake. The Blackrocks are a leaping point into Lake Superior at famed Presque Isle Park in Marquette. The two brewers got their start homebrewing for several years. Both men are from the Upper Peninsula and first returned home to work at a pharmaceutical company. With the coming of the national recession, they were let go and had to look toward a new career, or reboot, as they have called it. They combined their love for brewing with new careers.

Blackrocks Brewing Company opened on December 28, 2010, in a refurbished house with orange trim at 424 North Third Street in Marquette. The preceding six months had been a herculean task of going through the licensing and getting a one-barrel system started in the basement. When they first opened, they served beer until they ran out. Since that time, they have grown dramatically.

They went to a three-barrel system and hired two brewers, Andrew Reeves and Chris Hutte, who know their trade. Next they added a patio to the taproom, which is filled with guests on warm and even some not-so-warm evenings. By the summer of 2014, they decided to expand to the second floor of the house and to develop a larger parking lot. At all times, Dave and Andy "really wanted the brewpub to be a snapshot of what UP living is and what we're all about." For instance, they love to ski and hike, and this shows up in their unique fence decoration—hand-me-down skis from patrons—which adds color to their parking lot.

This philosophy has had an effect on patrons, many of who see the brewpub as a second home. The brewpub's patrons range in age from twenty-one to ninety-one, and the brewpub attracts beer drinkers from the neighborhood and from afar, as tourists find their way to a good brew. The brewpub's mug club started by accident, grew from 50 members to 1,400 and has run out of shelf room for the handcrafted mugs.

The most popular beers are 51-K, Coconut Brown and Grand Rabbits Cream Ale, which is served in the brewpub and is now distributed throughout

the Upper Peninsula, Lower Michigan and northern Wisconsin.

Many customers who enjoyed the beer produced at Blackrocks wanted to take home the product in larger amounts than growlers. In 2013, the owners took another leap and decided to expand and start canning beer. The company purchased the old Coco-Cola Bottling Plant on Washington Street and opened this new facility. Before the expansion, the brewery was producing 1,000 barrels a year. With the expansion, it was in the 4,000 to 4,500 barrel range. Now, Blackrocks beer is distributed throughout the Upper Peninsula and into the Lower Peninsula, where it is in strong competition with the brewers of Traverse City, Saginaw and Grand Rapids. The story of Blackrocks is a leap forward from economic adversity to a growing and bright future in the world of craft brewing. The owners have promoted the philosophy, "When you say you're a Michigan brewery—you want to make sure that it's something that makes people say, 'Michigan makes great beer.'"

Since its start, the owners have promoted community involvement. They have donated to various benefits. One of the major beneficiaries is the Noquemanon Trail Network, to which they make a sizeable contribution through sales of their 51-K beer.

Chocolay River Brewery

The Chocolay River Brewery is named after the Chocolay River that passes by, only yards from the Bayou Bar and Grill located in the Marquette suburb of Harvey. It had a grand opening in August 2014. The bar and grill has been a family operation since 2004, overseen by owner Tim Soucy, his sister Chere Snyder and their families. Tim, who had been homebrewing since 1990, and Chere decided to open the brewery in 2013 because "people around here love craft-brewed beer."

In March 2014, Soucy purchased stainless steel fermenters and equipment from Psycho Brew in Grand Rapids. The brewery has a five-barrel system that produces 155 gallons at a time. Soucy, as other brewers do, gives his beers a public taste test to see what is popular and sells and then produces what the public demands. The brewer is Grant Lyke, who first homebrewed for eight years and, between 1996 and 2012, was the brewer for Jasper Ridge Brewery. The staple beers are Gichigumie Black Ale, Shot Point Wheat, Blast Furnace IPA, Bayou Blonde, Rock Cut Pale Ale and Breakwall Blueberry Wheat. The brewery also produce seasonal beers.

The Bayou Bar and Grill is a restaurant with a full service bar. Their large

variety of bottled beers has been reduced to focus on their house brews which are served on tap or are available in growlers.

Ore Dock Brewery

Located two blocks from and within sight of the massive ore dock No. 6, the Ore Dock Brewery was opened on May 24, 2012. The proprietors, Andrea and Wes Pernsteiner, who were originally biomedical engineers, got interested in homebrewing. They toured Europe and the United States, investigating how brewpubs had developed as centers of local culture and conversation. When they visited Marquette, they were taken in by the community and felt that it would be the right location for their planned brewery.

After a careful search of the community for the right location, they found a rundown auto garage on the margin of the downtown area. This was perfect for their new brewpub. They added to the ambience by recycling timbers and metal from the garage into decorations and furniture for the pub. This inspired them to name their most popular beer Reclamation IPA.

The brewer, Nick Van Court—a native of Daggett, Michigan—was first introduced to imported German lager by his grandfather. He also has Marquette ties, having graduated from Northern Michigan University in 2004. He trained at the World Brewery Academy and returned to Marquette in 2011 to become associated with the Ore Dock. Now he oversees a ten-barrel system and focuses on Belgian-style beers. Nick stresses that the process in the brewery is what sets them apart from other breweries. He is tight-lipped about the process but not about the ingredients, which he freely talks about. For instance, their gluten-free beer, called Good Grist, is made with barley malt, which goes through a special process to ensure the beer is 100 percent gluten free. The process remains a trade secret.

The annual production of the brewery is 850 barrels, with ten beers on tap. Their staple beers are Belgian Blond, Dream Weaver Belgian (with citrus and chamomile), Saison (7.2 percent ABV), Radler and Good Grist. The most popular beer is Dream Weaver. The brewery started brewing for local consumption but began to bottle and distribute three of its brews in 2014.

The Ore Dock has proven a success and has become a Marquette focal point and tourist destination. The brewpub is popular with cyclists as it is right off of Marquette's paved bike path. The Pernsteiners have opened the second floor to community events and fundraisers, stressing

the visual and musical arts. Besides its fine array of beers, the brewpub only serves popcorn.

Martin Vierling (right), proprietor of the Vierling Sample Room, and a bartender. Typical of the time, Vierling was a German immigrant. Marquette, Michigan. *Courtesy Superior Views.*

Vierling Restaurant and Marquette Harbor Brewery

In the late nineteenth century, Martin Vierling, who was born in Bavaria in 1840, immigrated to the United States. He opened a saloon at the present location of the Vierling Restaurant in downtown Marquette. Terry Doyle from downstate Michigan had visited Marquette and, in 1982, decided to become a permanent resident. He wanted to establish a restaurant and found that the Finlandia Bakery on the site was up for sale. While walking through the property, he saw a sign, "The Vierling Saloon and Sample Room." He bought the bakery and then learned the Vierling story. He soon heard from a Vierling relative, Louis IV, and bought artifacts he had and later purchased an antique bar that had been stored and was in good condition. Doyle was ready to open a new Vierling saloon in 1985, but he could not because he did not have a liquor license. He decided to develop a restaurant base to his enterprise and then add the saloon.

Doyle, as others, was following the development of the craft brewing industry in Michigan. He saw wealthy people opening breweries that produced a poor quality brew and quickly closed. These people did not realize that you had to have a love of brewing and a desire to pour yourself into the process as an artisan.

Led by the philosophy that "people like good beer" and the fact that the closest brewpub in the Upper Peninsula was Hereford and Hops in Escanaba (some seventy miles to the south), Doyle acted. The brewing equipment was imported from Budapest, Hungary, and installed while a brewer oversaw brewing for three weeks. Then they were on their own. Derek "Chumley" Anderson was working in the kitchen and followed recipes extremely closely. He was interested and quickly learned the brewing process. He is now the longest-serving brewer in one location in the state of Michigan. Doyle considers him a great brewer, primarily because of his attention to detail and the excellent finished product he produces.

They started out with red ale, amber ale, pale ale and wheat beer. Every July, Marquette has a Blueberry Festival, and Doyle was asked if he could make a blueberry beer. Chumley got to work and produced a blueberry wheat. It was supposed to be made in a limited amount, but it quickly became very popular and was so in demand that it is now a regular beer in their repertory. Other breweries have followed suit.

The Vierling remains first and foremost a restaurant and secondarily a brewery. It has become known throughout the Midwest and beyond for its whitefish dishes. It is a comfortable place, filled with history, overlooking Lake Superior in an ideal location on the corner of Front and Main Streets. As a result of the atmosphere, food and fine brew, when you visit the Vieling, your stress level drops.

Munising

Shooters Firehouse Brewpub and Pictured Rocks Brewing Company

The brewpub is located in downtown Munising at the gateway to Pictured Rocks National Lakeshore. Donna Kolbus originally opened the restaurant in 1995 in downtown Munising and moved it to the present location in 2009. Kolbus is from a fourth-generation firefighting family, and to her delight, the Munising fire hall opened across the street. The brewpub incorporates firehouse memorabilia. Brewer Wes Daniels established the brewery, in April 2012, in a converted car wash. The brewery has a unique setup in which the brewer uses a half-barrel Brew Magic system and the taps run off five-gallon cornelius kegs. The system is tucked into the adjacent laundry. To Kolbus and Daniels's surprise, during the first

summer months of operation, they frequently ran out of beer. You can expect six brews on tap, which include fruit-infused wheats, smoked brews and an English pale. The newest brewers, Jill and Chris Gethers from Marquette, began work in 2014.

Besides the pub's beer, it serves a typical pub menu, and it has an outside deck and enclosed yard for private parties and yard games and a private loft lounge that seats twenty-plus people. The pub is a community center, which attracts both locals and out-of-town guests who find the atmosphere friendly and convivial. Kolbus has been surprised by the intense interest of craft beer drinkers who visit and enjoy Shooters' beers.

PARADISE

Tahquamenon Falls Brewery

"A brewery operating in a state park? How can that be?" many people have asked. The Tahquamenon Falls Brewery has an interesting history and is surrounded by the state park, about a mile hike from upper Tahquamenon Falls, the highest waterfalls west of Niagara Falls and a popular tourist attraction. It is the only state park in Michigan with an adjacent brewery and is probably the only state park in the nation with such a designation.

The story of the development a brewery at the falls goes back to 1949, when Tahquamenon Falls was only accessible by boat. Jack Barrett, who enjoyed the environment, purchased 164 acres of cut-over timberland from the Barrett Logging Company, which included access to the falls. Then he donated all but two acres of this land to the state, retaining the two acres for himself. With this donation, along with other donated parcels and state purchases, the forty-thousand-acre state park was created. Barrett negotiated a restriction in the deed for a road and parking lot that would allow visitors to walk to the falls, thus retaining the virgin forest surrounding the falls. His idea was to have visitors enjoy the hike to the falls and then enjoy refreshments on their return to the parking lot.

As a child, Lark Ludlow and her family enjoyed spending summers with their grandfather Barrett. He was a wonderful storyteller, knew the woods and got his grandchildren to share his love.

Barrett died in 1959, and his grandchildren, siblings Lark and Barrett Ludlow, acquired the two acres of property in 1987. Three years later, they

Lark Ludlow, proprietor of and brewster for the Tahquamenon Falls Brewing Company. Paradise, Michigan. *Courtesy R.M. Magnaghi.*

demolished the original buildings on what was known as Camp 33 and replaced them with a modern gift shop and snack bar.

Over the years, Lark developed her career and moved to upstate New York. There, she worked in corporate human resource management for several large corporations. All along, she remembered the wonderful summers she spent in the north woods and finally decided to make a change in her career. Her brother had moved back to the falls and opened a gift shop and snack bar and left his career in weather reporting aside. So, in 1996, Lark opened the Tahquamenon Falls Brewing Company and restaurant. This was a new venture, one that she had little experience in pursuing, but she did have corporate experiences that would help her.

The brewery was planned as a year-round venture, which was a step into the unknown since the closest towns are Newberry and Paradise—both of which have small populations and are away from the major M-28 highway. However, she pushed on. What was important was that Lark had fine, clear and clean water coming from an eighty-five foot well and, as she puts it, the "perfect water for brewing." This was important because urban breweries

have to deal with chlorine-tainted water. Next, she purchased a ten-barrel system but then found that the Hungarian company went out of business and did not leave her with an operational manual. Since Lark had never homebrewed, she was at a loss without recipes and the technical knowledge of brewing or the operation of the equipment. Terry Doyle, the owner of the Vierling Restaurant and Marquette Harbor Brewing Company in Marquette, came to the rescue. He allowed his brew master, Chumley, to aid Lark and get the brewery going. She started with a Bohemian-style beer, a red beer, and she continues to brew beers on the lighter side. Soon after she developed the brewing process, she developed blueberry wheat ale and shared the recipe with Chumley; it's now a mainstay at the Vierling.

Once the plant was in operation, she, as many brewers in the Upper Peninsula, had to attract a clientele, many of whom were used to drinking the national brands like Budweiser or Coors. It took her a while to cultivate the customers' tastes to craft beer. She would walk around the pub with a tray of little samples and ask them to taste the beer. Most liked the microbrew and were sold on the new taste experience.

Although she had some customers, the brewpub was far from centers of population, so how did the brewery become a success? For one thing, she opened a restaurant. Once again, she had no culinary experience but pushed ahead with determination. She now operates the brewery and restaurant and oversees some forty employees both permanent and seasonal. The idea of a year-round operation had to be curtailed. There are two slow seasons that she has to face. The first is the hunting season, which in Michigan runs for two weeks starting on November 15. This should be a busy time, but that is not the case because Upper Peninsula deer hunters hang out in their camps with friends and relatives and drink store-bought beer and other beverages. So, the brewery closes from the third Sunday of October to the middle of December and again during the month of April, which proves to be a dead period with no customers.

The wilderness location attracts cross-country skiers, snowmobilers, dog sled racers and visitors to local festivals and, naturally, to the falls. Paradise has a winter festival, and in the summer, there is a blueberry festival and a fall cranberry festival. People from around the world have been attracted to the brewpub and restaurant, seeking good beer and food in this unlikely north woods location.

The brewery's unique history and location have made it popular with visitors to the falls. In another unusual twist, Lark likes to point out that in the European tradition, women are the brewers, and she remains the brewster. Lark can relate to Mary Lisle, the first unofficial brewster in America, who, in 1734, took over her late father's Edinburgh Brewhouse, in Philadelphia,

Pennsylvania, which she operated until 1751.

SAULT STE. MARIE

Soo Brewing

Soo Brewing is the only brewery and brewpub with the name of an earlier brewery at Sault Ste. Marie in the eastern Upper Peninsula. Since the original Soo Brewery had closed in 1948, the name was readily available when Ray Bauer incorporated in 2009.

The brewery was Bauer's dream. He first made beer from a homebrewing kit in 1990 but found that it was a difficult process, and the proper ingredients—malt, hops and yeast—were difficult to come by through homebrew stores. Between 2004 and 2010, he got back into brewing in order to become an expert in the process. He followed scientific methods, consulted with chemist friends and brewed to master the art of brewing. He tried many new recipes, blending hops, yeast, malt, water and extracts to seek the best beer. Before he could call himself a professional brewer, Bauer brewed several hundred beers. He also moved to Sault Ste. Marie, where he found that there were no local breweries, the closest being at Tahquamenon Falls and Grand Marais to the west. If these two locations could exist around small populations, why not one at the Soo? Furthermore, there were few people brewing in the area.

When Soo Brewing opened in 2011, Ray was faced with a problem. As he puts it, "The locals were Bud drinkers." If he first presented them with a strong IPA, their first and only response would have been, "Oh, that craft beer is too bitter" or, "He just sells that dark stuff." He would have to take action to attract the locals and provide them with a transition beer to get them into his establishment and then he could keep them there. Afterward, he slowly introduced a stout and then an IPA, and he "sold" his beer to the public. Demand for his brew spread. As with all microbrewers, Bauer experimented with new beers to see what the public taste demanded and then followed the tastes of his customers. Since he started, he has brewed seventy-nine different recipes, eight of which are his big sellers, amounting to half the beer he sells. He also brews several seasonal beers and rotates them on and off tap. The other seventy-one recipes make up the other 50 percent. Between May 2013 and 2014, his business grew by 20 percent.

As with many of these craft brewers, Ray had an interesting

background. He was first trained in college as a journalist and then he was a successful broadcaster before he lost his job to computerization of the broadcasting industry. Luckily, he was brewing in his spare time. Then fate intervened. He was terminated from his job and saw brewing as a natural outlet.

Bauer's business went through some interesting developments. As his establishment developed, he found that his business reached its capacity. The only way it could expand was through offsite beer sales. The growler entered the scene and soon became an important part of his success. In June 2014, Soo Brewing sold one hundred growlers in a day for the first time. Ray is concerned about amber, or colored, growlers, thus, offers only clear growlers in his taproom. He says colored growlers can harbor mold and bacteria, which alter the beer's flavor, and as a result, the customer blames the brewery and not the condition of their growler. Thus, Soo Brewery only offers clear growlers and will take clean returns, which has proved successful.

An important ingredient to his business is the mug club that developed. Some four hundred muggers have their own twenty-ounce mugs. During the slow months, muggers provide up to 40 percent of Soo's business.

Soo Brewery is not in the business of canning its product. Ray sees brewing as a fun business, and brewing allows him to pursue his interest in new flavors and types of beer. The canning process would demand his adherence to a few beers that could not be varied. There was also the question of cost for a larger brewing operation, canning equipment, a distributor and sales site. Bauer decided to open a new brewery and corporate entity a block to the east of his home establishment.

The Soo Brewery has had an impact on the local economy and society. The business itself has brightened the street and made it more alive. It has brought people and excitement to a section of town that was quiet and rather dismal. The local momma-poppa pizzeria, Upper Crust Pizza, has seen its business increase substantially as beer patrons order pizzas. The brewery has contributed to the Summer Solstice 5K, girls' softball and Soo Little League and provides money from the sales of root beer to local historical sites.

The brewery has attracted a new and diverse clientele. People who would not otherwise go into a local bar are attracted to Soo Brewery. Professionals such as physicians, attorneys and professors mingle with crew from the icebreaker *Katmai Bay*, border security, locals and tourists. It is a diverse group that, without the brewpub, would likely not interact and get to enjoy each other's company. The busiest day of the year for the brewpub is not St. Patrick's Day or New Year's Day but the day before Lake Superior State University commencement.

Further adding to the conviviality of the pub is the Fraternal Order of Cheese, which was started when a mugger brought in some cheese on a Monday evening. This club has grown with a variety of cheeses, venison jerky and other eatables brought in. Nonmembers are asked to contribute to the pot and everyone has an enjoyable evening around fine beer.

Through all of this enterprise, Bauer concludes "I love coming to work and I love brewing. I brew several times a week and I haven't gotten tired of it yet and I don't think I ever will, because this is what I did on my days off for many, many years before I ever became a brewer, so this was my hobby to begin with."

Lockside Brewing Company

A block from the St. Mary's River locks, the Lockside Brewing Company, Limited and 1668 Winery was opened in early 2015. (The year 1668 is the year Sault Ste. Marie was founded.) The brewpub was established by Ray Bauer, and it has a two-barrel capacity. The new operation sells wine, beer and food, has a deck and, as Bauer says, it is for "grown-ups." It also provides an outlet when the original brewpub is filled. As Bauer puts it, the new establishment provides a new experience for patrons, especially with the addition of television, which he does not allow in the Soo Brewery.

THE CONTEMPORARY SCENE

In 2014, Michigan ranked fifth in the nation in number of breweries, behind California, Colorado, Oregon and Washington. This is an entrepreneurial-driven industry, which provides more than $24 million in wages and has an economic impact of $133 million overall. The law in Michigan and elsewhere has been influenced by post-Prohibition restrictions that make it difficult for Michigan and Upper Peninsula brewers to navigate the legal brewery landscape. Many of these laws were created for valid reasons, but after more than eighty years, some of today's regulations from the Liquor Control Commission are considered archaic, hindering the further development of a multibillion-dollar industry. The Michigan Brewers Guild has been successfully working with brewers and legislators to get these laws revised, changed or eliminated.

As craft brewing becomes an important part of the national and local economy, there is a growing demand for ingredients, the assistance of master brewers and training for new brewers. All three are being met in the Upper Peninsula and in the state of Michigan.

HOPS

Hops (*Humulus lupulus*) is a perennial vine that grows up to thirty feet. It contributes the aroma and bitterness to beer, which is prevalent in Indian

Pale Ale (IPA). The center of hop cultivation is the Pacific Northwest. At the time of the Civil War, hops were an important crop grown in Michigan, especially in the Traverse City area. Then there was a significant decline, due to the infestation of the hop louse, and hop farming moved to the Pacific Northwest. Wild hops are found in both peninsulas, but since their variety is unknown, they cannot be used for brewing.

As the craft beer industry has expanded, there has been an increasing and serious demand for hops. Michigan farmers have begun once again to cultivate hops. Rob Sirrine of the Michigan State University Cooperative Extension said that currently more than four hundred acres of hops are under cultivation in Michigan. The farms are found on the Leelanau and Old Mission Peninsulas in the Traverse City area and in Lower Michigan. The Michigan Hop Alliance was founded in 2011, and its grower-members are working to produce high-quality, sustainably grown hops for brewers and homebrewers in the Midwest.

Jim Korpi of Rock, north of Escanaba, is the largest grower of hops in the Upper Peninsula. He started with a modest two acres of hops and plans to double the acreage, to eventually have eight acres. Korpi's hops grow eighteen feet tall and survive the harsh UP winters. He points out that you have to have a passion to grow hops because it is costly for harvesting equipment and processing hops on a commercial basis. With his crop, he supplies UP breweries and stores for homebrewing. Korpi also sells rhizomes of plants to anyone interested in growing monster plants.

USE OF MASTER BREWERS

The original small and scrappy homebrewers that started the movement, now craft brewers are concerned about consistency of their product. Many of the new brewers are turning to employees of such brewing giants as Anheuser-Busch and MillerCoors to tap their expertise in producing a product that has a consistent flavor and quality over the long haul. This is important because in 2013, the sale of craft beer rose about 17 percent despite a nearly 2 percent decline in overall beer sales, according to the Brewers Association, a trade group of more than three thousand breweries in the country. The craft beer drinker expects consistency or breweries risk the loss of customers. As Tim Hawn, formerly of MillerCoors, has stated, "People will put up with a little bit of variability, but it's not like it used to be. Obviously folks

are willing to pay for the luxury of craft…and for that luxury they expect to have that same experience every time they enjoy a beer." To date, it is not known that outside beer experts have been hired by Upper Peninsula breweries, but this is a possibility.

Academic Origins

Over the years, a number of alumni from Northern Michigan University have graduated and found employment in the microbrewery industry. Some of them worked in a brewery for a while and then moved on, but not Aaron Morse, a 1997 fine arts graduate. He and his friends concocted batches of brew in a basement dorm kitchen. "We were tired of drinking the same old stuff, and money was an issue, so we came up with the brilliant idea of making our own beer," he said. One time, students were protesting against alcohol and drugs right outside their dorm. When a couple of students came in and asked what they were making, a culinary arts student said, "Beef comsumé," but the protesters were not interested in tasting what amounted to sugar water at the time. On another occasion, they were making beer in the dorm bathroom, and a fire drill took place. They had to leave all of the beer-making equipment—burners, pots, bags of corn, sugar—in the room. They stood waiting for the all clear, worrying about the repercussions of getting caught, but the resident adviser did not bother them.

Aaron did an "apprenticeship" with a brew master in Lower Michigan. He took used equipment and established a small brewpub in Marshall, Michigan. This small endeavor has grown into the Dark Horse Brewing Company, which distributes to a multistate area. In 2013, RateBeer listed it as number twenty-nine in their list of Best Brewers in the World, and in July 2014, the History Channel came out with the production *Dark Horse Nation*. Morse points out that his art background helped him design labels and the logo for his brewery. This is not bad for a college student who got his start making homebrew in his college dorm in the UP.

Academic Program

There have been discussions on the college-level to create programs and certify experts in "fermentation science." At Central Michigan University, the dean of the College of Science and Technology, Ian Davison, announced plans to launch such a program in the fall of 2015. It is the first undergraduate program in the state "specifically aimed at providing a hands-on education focused on craft beer." The program director, Cordell DeMattei, said it "will fill a need in the state and across the region for students to learn the science and technology underlying brewing…and provides the training needed by future leaders of the craft brewing industry."

In 2013, *Michigan Beer Film* was completed by director Kevin Romeo of Kalamazoo-based Rhino Media Productions. He premiered the film in Kalamazoo and then Detroit in March 2013. It is a two-hour documentary, and it explores the creative ways Michigan craft beers are made and the colorful people behind them. The Freep Film Festival was held at Fillmore Detroit and was attended by six hundred patrons. This is an indication of the role of craft beer and its interest in the state at large.

Brewing has become not only an important industry in the Upper Peninsula, but it has also attracted attention from the general public. The local newspapers, like the *Marquette Mining Journal* and the *Escanaba Daily News*, frequently carry stories highlighting the latest developments in the industry on a local level. On a more academic level, the Northern Michigan University Beaumier Heritage Center put on a historical display entitled "What's On Tap: Brewing in the U.P.," which ran from April to September 2014, highlighting brewing in the region. This was one of the few such exhibitions to be held in the Upper Peninsula but shows the interest in historic and craft brewing.

The Michigan Brewers Guild hosts four beer festivals around Michigan during the year. The winter and summer beer fests in Grand Rapids and Ypsi/Ann Arbor receive media buzz and attendance due to their proximity to large urban areas—Chicago and Detroit. Since 2008, a September festival has been held in Marquette, which is isolated from large urban areas and doesn't have interstate access. The U.P. Fall Beer Festival takes place in Mattson Lower Harbor Park in downtown Marquette, overlooking the blue waters of Lake Superior. More than 340 beers from 53 breweries are available in the tent city that emerges. Area restaurants provide food, and sippers can listen to a talented line-up of musicians. The festival is extremely popular with the public, attracting as many as 1,600 visitors and brewers

who have an opportunity to show off their beers. As one observer noted in 2013, "If you like good beer, the U.P. Fall Beer Festival in Marquette is a grownup's version of Disneyland."

The community of Curtis in the eastern Upper Peninsula is always actively promoting itself and its art and heritage. In 2006, they held their first Oktoberfest, which has become an annual event promoting beer.

The local breweries provide an opportunity for attendees to sample beers that they might have difficulty getting as they are not bottled or canned. Hereford and Hops from Escanaba showcased a smoked jalapeño beer in 2013. They also brought a blueberry lemongrass ale. As an online article by "Seth" concluded:

> *Everybody understands that the barriers to entry for attending the U.P. Fall Beer Fest can get cumbersome. That's why a successful Fall Beer Fest has less people than a Summer or Winter Fest. But that's what endears it to so many craft beer fans; the people who go to the U.P. really want to go there, they want it enough to make the trip from below the bridge or from the mountains to represent Michigan Yooper culture.*

The various local brewers in Marquette showcase their beers and present new beers for the public's taste and enjoyment. In 2013, brew master Derek "Chumley" Anderson at the Vierling Restaurant and Marquette Harbor Brewery presented the most popular brew, Blueberry Wheat, but added Cocoa Mocha Porter, Honey Ginger IPA and collaborated with Black Rocks Brewery and produced Big DIPA, a double IPA with grapefruit zest.

The owners of Black Rocks Brewery, Andy Langlois and Dave Manson, served up some featured favorites at the festival: the Coconut Brown, a creamy, rich brew with a subtle coconut finish; 51K IPA, an American IPA with an herbal aroma, a fruity-resin flavor and grapefruit finish; Grand Rabbits (dry hopped) Cream Ale; Flying Hippo Imperial Belgian IPA; Samosep Amber; Chocolate Wheat; Dennis the Doggenbier, a firkin (eleven gallons) of Saison; and the Laser Wolf Doom Hammer Spruce Juniper Imperial IPA, a mouthful to say and drink.

Some of the beers that Black Rocks unveiled to beer drinkers at a previous festival became favorites with Black Rocks patrons. These beers include Drunk Yoda Amber, Willie O'Ree Black Ale and Honey Lavender Wheat and are regularly found on tap. The latter became so popular that it is canned as a seasonal beer.

The third Marquette brewery to attend the 2013 beer festival was the Ore Dock Brewery. As Nick Van Court noted, they presented, "the King's English which is cask-conditioned—a fermenting process that originated in England, where brewers added carbonation to ales by adding yeast to a cask and allowing it to age, thus producing an English-style ale with a subtle taste, less carbonation and a long, electric aftertaste." To name a few other beers that were included: Inspiration Point, which was aged for seven months in a merlot barrel; Little Red Gluten-Free Beer; Berline Weiss, a traditional take on a German extreme pale ale; Small Sail Ale, a British-style summer ale; and the Ore Dock IPA and Saison. This is a partial sampling of the brews that have been offered at the U.P. Beer Festival in the past, and the tradition continues.

UP Craft Beer Week was organized in 2012 by A Point Above, founded by Jamie Strand of White's Party Store in Marquette and Josh Marenger of Bay de Noc Brewers. This complements and culminates with the U.P. Beer Festival at the end of the week. During the week, breweries and restaurants promote food and drink. It has been a growing success.

BREWERY TOUR/BEERCATION

The brewery tour beercation for beer aficionados is a growing industry. Beer drinkers come to the Upper Peninsula with the breweries as their destination. One swift tour was pioneered by Ray Bauer of Sault Ste. Marie since he did not have time to make a slow trip but wanted to see his fellow brewers. He and his family left Sault Ste. Marie on day one and traveled to Tahquamenon Falls, Grand Marias, stayed in Calumet at the Michigan House and then proceeded to Brickside at the end of US-41 in Copper Harbor. The next day they traveled to Marquette and Ishpeming and checked out the breweries there before heading to Escanaba's Hereford and Hops and then back to the Soo. The Upper Peninsula's breweries and brewpubs have become another reason to visit the region and enjoy its local beers. As a result, a number of books have been published to guide the beer tourist to the sites.

HOMEBREWING

A number of homebrewing clubs have developed in the Upper Peninsula. The largest is Bay de Noc Brewers, located in Escanaba, which goes back nearly a decade. Their major promoter is Hereford and Hops. The members meet to discuss tips and techniques of brewing, recipe formulation and demonstrations. In 2009, at Jack Mellinger's farm, they were treated to a creation of Maple Nut Brown Ale using maple sap instead of water. This produced a brew with 4 percent alcohol. The club also celebrates Big Ole Festival and National Mead Day.

The UPoberfest has been held since 2005 and is the only beer and wine festival in the region. It is held at Hereford and Hops and raises money for United Way.

Interest in homebrewing hit Marquette, and in November 2013, the Marquette Home Brewers was established. The organization started informally with eight to ten people, and as word spread, it quickly grew to thirty people and continued to grow. Since its inception, it has hosted many events, recipe sessions and beer making contests, the winner of which is declared the "Home Brewer of the Year."

BREWERIANA

A topic that is not usually discussed is breweriana, which refers to collectable items associated with a brewery or one of its brands. The collected items include beer cans and bottles, bottle openers, beer trays, wooden boxes and all types of signs. These items are declared rare when the brewery had a short existence. Throughout the Upper Peninsula, there are collectors with rare collections. Some of these collectors comb local dumps for bottles and are successful in their endeavors. Most of these collections of breweriana remain in private hands, while a smaller number of items can be found in museum collections. These items are extremely useful to researchers because, in many cases, the only record of a brewery's existence is on the bottle with the brand name and location. A collector who is knowledgeable about the type of bottle can give an historian a good idea of when the little-known brewery operated. In some cases, the beer trays, which are rare, have colored lithographs of the former brewery drawn from an aerial perspective. The collector plays an important role in preserving the history of brewing.

Impact of Craft Brewing

A number of positive results have come from the development of craft brewing. The first development is economically centered. As in the past, brewing has become a major economic stimulant throughout the nation, the state of Michigan and the Upper Peninsula. Since 1993, when brewer's licenses became available in Michigan and the first brewpub—Hereford and Hops—opened in Escanaba, seventeen breweries have opened across the Upper Peninsula. They exist in a variety of locations from the most northerly brewery, Brickside at Copper Harbor, to the most remote, Tahquamenon Falls, to the majority of breweries in larger cities. They vary from small operations with or without restaurants to operations like Blackrocks and Keweenaw, the canned beers of which are sold in Michigan, Wisconsin and beyond. Whatever their capacity or size, the breweries have stimulated the local economy. In Marquette, Blackrocks moved into a deserted Coca Cola plant while at Atlantic Mine, which had seen better days during the mining boom, Keweenaw found ample space for its plant, and the community saw its tax base rise. The brewpub has been an economic boon to communities. In Houghton, Michigan Tech administrators use the Keweenaw pub as a reason why new faculty should take their job offer. Naturally, the production and sale of beer brings tax revenue to the federal, state and local governments. Old or vacant structures have been put to use as brewpubs, and the area around them has been raised from a declined state. Since the first brewery opened in the Upper Peninsula, none of them has failed financially, and for many of them, expansion is their byword.

For over a century, breweries have promoted themselves as family friendly and beer as a healthy and nutritious beverage. The beer garden, taproom or pub is a place where people can meet and have a convivial time with friends. The other element that makes a pub fun to visit is the attitude of the proprietors who completely enjoy making beer and experimenting with flavors and varieties. This joie de vivre, or keen enjoyment of life, is quickly picked up by customers. The brewpub has quickly become like the coffeehouse a place where people can relax, talk and enjoy a beverage. The brewpub attracts a wide variety of people in different stations in life who come together to enjoy a beer, meet and enjoy each other's company. In most circumstances, these people would never meet outside of a brewpub. Mug clubs have developed in many pubs, which have the effect of stimulating conviviality and cash flow, especially in the winter months.

So in the end, we see that brewing has had a long tradition in the Upper Peninsula and now continues on an extremely positive and optimistic note. Those German brewers and immigrants who came to the Upper Peninsula in the nineteenth century knew what they were introducing American society to.

BIBLIOGRAPHY

Bald, Clever F., ed. "From Niagara to Mackinac in 1767." *Algonquin Club Historical Bulletin* 2 (1938).

Batdorff, Allison. "Beer Harvest: Empire Celebrates a Brewski Essential." *Traverse City (MI) Record-Eagle*, sec. C, September 18, 2014.

Blum, Peter H. *Brewed in Detroit: Breweries and Beers since 1830*. Detroit, MI: Wayne State University Press, 1999.

Brown, John H. *Early American Beverages*. New York: Bonanza Books, 1966.

Bystrom, Esther B. "The Beer that Made Marquette Famous." *Harlow's Wooden Man* 5, no. 4 (Fall 1969): 6–7.

Eustice, Sally. *History from the Hearth: A Colonial Michilimackinac Cookbook*. Mackinac Island, MI: Mackinac State Historic Parks, 1997.

Evans, Kristi. "A Dark Horse Taps into a Bright Future." *Horizons* (Winter 2006): 18–21.

Franklin, Dixie. "Brewing Served Up Beer of Many Names before Keg Ran Dry." *UP Sunday Times Upbeat*, April 15, 1979, 16–17.

Gianunzio, Fiore. *Mangia Ferro! "The Iron Eater": The Story of a Rugged Italian Immigrant and His Family in the 20th Century*. Iron Mountain, MI: Piers Gorge Press, 1999.

Goodman, David N. "CMU Launches Beer-Making Program." *Marquette (MI) Mining Journal*, September 25, 2014.

Gwidt, J. Michael. *Mining Beer, History of Breweries in Michigan's Copper Country*. N.p.: privately published, 2000.

Hamil, Fred, ed. "Schenectady to Michilimackinac, 1765 and 1766: Journal of John Porteous." *Ontario History* 33 (1939): 75–98.

Hobart, Henry. *Copper Country Journal: The Diary of Schoolmaster Henry Hobart, 1863–1864.* Edited by Philip P. Mason. Detroit, MI: Wayne State University Press, 1991.

Kalm, Peter. "The Method for Making Spruce Beer as Practiced in North America, from the Letters of P. Kalm Sent to the Swedish Academy." *Gentleman's Magazine and Historical Chronicle* 22 (September 1752): 399–400.

———. *Travels in North America.* Edited by Adolph B. Benson. New York: Dover Publications, 1987.

"Keweenaw Brewers—Hoppy Together." *Marquette Monthly* (May 2009): 37–41.

Kless, Nancy. "Something Brewin in the UP." *Marquette Monthly* (September 1995): 18–19.

Komula, Roger. "Beer Was Dear to Region." *Houghton (MI) Daily Mining Gazette*, March 26, 1994.

Lancour, Jenny. "New Regional Brewery Nearly Ready." *Marquette (MI) Mining Journal*, August 29, 2014.

Lankton, Larry. *Beyond the Boundaries: Life and Landscape at the Lake Superior Copper Mines, 1840–1875.* New York: Oxford University Press, 1997.

May, George S., ed. *The Doctor's Secret Journal.* Mackinac Island, MI: Mackinac Island State Park Commission, 1960.

McClelland, Lee. "U.P. Fall Beer Festival Celebrates Craft Brewing." *Marquette Monthly* (September 2013).

Michigan Beer Guide. Various.

Michigan: The Great Beer State. Various.

Monette, Clarence J. *The History of Eagle River Michigan.* Lake Linden, MI: privately published, 1978.

———. *Joseph Bosch and the Bosch Brewing Company.* Lake Linden, MI: Privately published, 1978.

Morand, Lynn L. *Craft Industries at Fort Michilimackinac, 1715–1781.* Archaeological Completion Report Series. No. 15. Mackinac Island, MI: Mackinac State Historic Parks, 1994.

Moran, Neil. "Demand for Hops Creates Niche for Farmer." *UP's Second Wave*, June 26, 2013.

Mosher, Randy. *Tasting Beer: The Insiders' Guide to the World's Greatest Drink.* North Adams, MA: Storey Publishing, 2009.

Nasiatka, Maryanne, and Paul Ruschmann. *Michigan Breweries.* Mechanicsburg, PA: Stackpole Books, 2006.

Nordberg, Erik. "From the Archives: The Bosch Brewing Company." *Michigan Tech* 43, no. 2 (Fall 2006).

Nordberg, Jane. "Microbrews with Micro Flavor." *Houghton (MI) Daily Mining Gazette,* June 1, 2005.

Old Copper Country Bottles of Michigan's Upper Peninsula. Calumet, MI: Copper Country Bottle Collectors, 1978.

Oliver, Garrett, ed. *The Oxford Companion to Beer.* New York: Oxford University Press, 2012.

One Hundred Years of Brewing. Special issue, *Western Brewer* 24, no. 8 (August 1901).

Quaife, Milo, ed. *The John Askin Papers, 1747–1795.* 2 vols. Detroit, MI: Burton Historical Records, Detroit Library Commission, 1928.

Revolinski, Kevin. *Michigan's Best Beer Guide.* Holt, MI: Thunder Bay Press, 2013.

Rupp, Rebecca. *Red Oaks and Black Birches: The Science and Lore of Trees.* Pownal, VT: Storey Communications, 1990.

"Sauna Beer Picked County Product of the Year." *Houghton (MI) Daily Mining Gazette,* April 10, 1968.

Smith, E. Ann. "Drinking Practices and Glassware of the British Military, circa 1755–85." *Northeast Historical Archaeology* 12 (1983): 31–39.

Smith, Gregg. *Beer in America: The Early Years, 1587–1840.* Boulder, CO: Brewers Publications, 1998.

Sneath, Allen Winn. *Brewed in Canada: The Untold Story of Canada's 350-Year-Old Brewing Industry.* Toronto, BC: Dunburn Group, 2001.

Straus, Frank. "History of Beer and Ale at Mackinac Island and the Straits." *Mackinac Island (MI) Town Crier,* July 26, 2013, 1–3.

Sundstrom, E.J. "Sault Brewery Thrived During Golden Age." *Sault Ste. Marie (MI) Evening News,* December 4, 1978.

Wardell, Mary and Justin Marietti. "U.P. Beer Guide." *Marquette (MI) Mining Journal* (Special insert), August 29, 2014.

Widder, Keith R. *Dr. William Beaumont, The Mackinac Years.* Mackinac Island, MI: Mackinac State Park Commission, 1975.

Worth, Jean. "Site of Many Breweries, Now Reduced to One Plant." *Marquette (MI) Mining Journal,* January 22, 1968.

———. "Stage Coach Operation in the UP." *Marquette (MI) Mining Journal,* August 27, 1968.

INDEX

ABOUT THE AUTHOR

Dr. Russell M. Magnaghi is history professor emeritus and former director of the Center for Upper Peninsula Studies at Northern Michigan University in Marquette, Michigan. He studied at St. Louis University and taught at NMU between 1969 and 2014. Known as "Mr. UP History," he has written extensively on this unique region of the United States, focusing on immigration, Native Americans and the university. In his classes, talks and publications, he has paid special attention to the food and beverages of the UP. Always enoying a fine brew, Magnaghi readily accepted the invitation to develop this in-depth study of brewing in the Upper Peninsula and pulled together this element of local history, which was nearly lost to future generations.